Disney's Aladdin

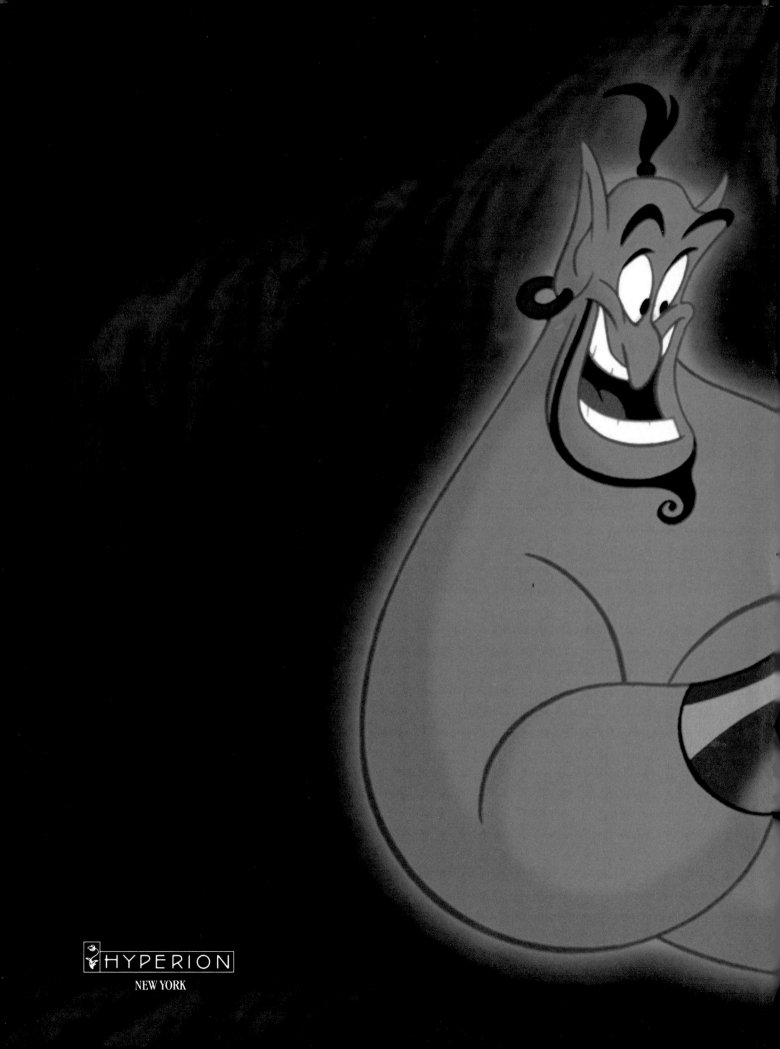

HYPERION
NEW YORK

DISNEY'S Aladdin
The Making of an Animated Film

by John Culhane
Designed by David Kaestle

Design Credits

Produced by: **David Kaestle, Inc.**, New York
Art Director/Designer: **David Kaestle**
Associate Designer: **Richard DeMonico**
Design Assistants: **Mark Hecker, Cathy Canzani**
Photography: **Michael E. Stern, David Lans, Andrew Taylor**

Special thanks to Heidi Miller of the Disney Publishing Group and Stacy Slossy and Cliff
Freitas and co-producer Amy Pell of Disney Feature Animation, and to Howard Green, Director
of Studio Communications for their tireless, knowledgeable and extremely good-natured help in
securing the hundreds of images that are presented in this book. And to Leslie Wells and Bob
Miller of Hyperion for their support and encouragement from beginning to end.

Extra special thanks to the dozens and dozens of animators, directors, designers, producers and
other Aladdin project personnel who gave up precious time during the production's final hectic
weeks to help us make this book as visually interesting as it is.

And finally, thanks to author John Culhane, whose vast knowledge of the art of animation
made our job easier and made the visualization more meaningful.

—David Kaestle

Culhane, John.
 Disney's Aladdin: the making of an animated film/by John Culhane.—1st ed.
 p. cm.
 ISBN 1-56282-892-4
 1. Walt Disney Company. 2. Aladdin (Motion Picture) 3. Animated films—United States. I. Title.
NC1766.U52D5324 1992
741.5' 8'0979793—dc20

92-28187
CIP

First Edition
10 9 8 7 6 5 4 3 2 1

Contents

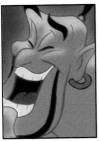
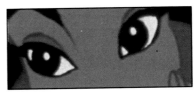
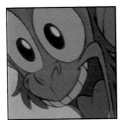
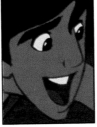

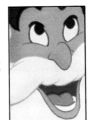

Acknowledgments

In the bazaar at Baghdad in 1969, I heard a *rawi*, the traditional Arab storyteller, tell the tale of *Aladdin* from the Arabian Nights, making me a witness to the oral tradition that has kept such stories alive for at least a thousand years. To my wife, Dr. Hind Rassam Culhane, formerly of Baghdad, and to her parents, Noel and the late Sophie Bakhazy Rassam, whom Hind and I and our sons, Michael and T. H., were visiting there, thanks. For my appreciation of the Disney tradition of animation, which has given tales from the oral tradition new life in the 20th century, I thank my parents, Jack and Isabel Culhane, for taking me to see the first Disney versions as they came out. But the greatest inspiration came from Walt Disney and his brother, Roy O. Disney, and the greatest encouragement from Walt's daughter, Diane Disney Miller, and Roy's son, Roy E. Disney. At the Walt Disney Company, Roy E. Disney, and Michael Eisner, Jeffrey Katzenberg, Peter Schneider, Erwin Okun, and coproducers/writers/directors of *Aladdin*, John Musker and Ron Clements, have often helped me to tell the Disney story in articles and books, and they have all helped me with this book. It was good to write it for Hyperion, named after the street where *Snow White* was made, and I thank Bob Miller, the publisher, who truly offered me a magic lamp when he offered me a contract for this book; and Leslie Wells, an editor of grace under pressure, and Ellen Cowhey, her assistant. *Aladdin* also gave me the opportunity to work with David Kaestle, a designer of rare imagination, with whom I did *Special Effects in the Movies* a decade ago; and his associates, Rick DeMonico and Mark Hecker.

The Genie appears in many guises. I gratefully recognize Kathy Altieri, Ken Anderson, Tony Anselmo, Ray Aragon, Debbie Armstrong, Howard Ashman, Rasoul Azadani, Tom Bancroft, Tony Bancroft, Jodi Benson, Carl Bell, Bill Berg, Aaron Blaise, Car'yn Bowman, Maurice Breslow, Dave Burgess, Virgil Burnett, Randy Cartwright, Mike Cedeno, Les Clark, Brian Clift, Jim Conner, Bill Cottrell, Penny Coulter, Shamus Culhane, Salvador Dali, Marc Davis, Andreas Deja, Tony Derosa, Alice Dewey, Ted Elliott, Don Ernst, Ray Favata, Brian Ferguson, Will Finn, Jonathan Freeman, Cliff Freitas, Raul Garcia, Eric Goldberg, Steve Goldberg, Ed Gombert, Gilbert Gottfried, Kent Gordon, Joe Grant, Charles Gregory, Joe Haidar, Dan Hansen, John Hench, Mark Henn, Al Hirschfeld (with memories of our dinner with Art and Barbara Babbitt), Renee Holt, Rick Hoppe, John Hubley, Ralph Hulett, Steve Hulett, Ray Huffine, Ron Husband, Rudy Ising, Ub Iwerks, Wilfred Jackson, Ollie Johnston, Bill Justice, Milt Kahl, Brad Kane, Glen Keane, Ward Kimball, Linda Larkin, Eric Larson, John Lounsbery, Duncan Marjoribanks, Charles Maryan, Bill Matthews, Burny Mattinson, Sylvia Mattinson, John May, Alan Menken, Kent Melton, Gil Miret, Mary Mosa, Clarence Nash, Grim Natwick, Paige O'Hara, Karen Paat, Gilda Palinginis, Don Paul, Bill Perkins, H. Lee Peterson, Tina Price, Dave Pruiksma, Nik Ranieri, Wolfgang "Woolie" Reitherman, Tim Rice, Robyn Roberts, Terry Rossio, J.R. Russell, Lea Salonga, Carmen Sanderson, Ariel Shaw, Douglas Seale, Tom Sito, Dave Smith, Sherri Stoner, Mike Swofford, Frank Thomas, Alex Topete, Ann Tucker, Bill Tytla, Richard Vander Wende, Frank Welker, Scott Weinger, Barbara Wiles, Thomas L. Wilhite, Rob Willoughby, Ellen Woodbury, Phil Young, and Kathy Zielinski.

Special thanks to Howard E. Green, Disney publicist whose love for Disney animation and animators equals mine, and his wife, Amy Boothe Green, for her knowledgeable transcriptions of my interview tapes, and the hospitality of their home.

INTRODUCTION

Think of the Possibilities

When I was seventeen, I made a pilgrimage from my hometown of Rockford, Illinois, to meet the person who had showed the world that the animated film was the great new art of the 20th century. On August 26, 1951, thanks to his daughter, Diane, I spent a summer Sunday afternoon with Walt Disney in the backyard of his home in Los Angeles, free to ask him anything I pleased. Two days later, at his invitation, I toured his studio and questioned his artists.

Being seventeen, I wanted to know everything, including exactly what Walt Disney was "after."

Like millions of people in every corner of the earth, I had grown up with Disney's first great pioneering successes: *Mickey Mouse, Three Little Pigs, Snow White and the Seven Dwarfs, Pinocchio*; the trailblazing concert feature, *Fantasia*; *Dumbo, Bambi, Cinderella*...Where was it all leading?

"Our most important aim," Walt Disney told me, "is to develop definite personalities in our cartoon characters. Without a definite personality, a character can't be believed. And belief is what I'm after."

I asked him how you give a character a personality.

"You want to know how we do it?" repeated Walt, looking at me with terrific intensity. He coughed, and raised an eloquent eyebrow. "Okay. Suppose you're creating a character called Peter Pan. Well, who the hell is he? Who is Peter Pan? What's he thinking? What does he want? How does he walk? Can we make him fly?

"What are we doing about it?" he asked, though I hadn't said anything. "Well, you just have to do it! You have to keep experimenting. Keep having meetings. Meetings of minds—and hearts. Keep talking. Keep trying. Keep making drawings. Keep throwing drawings away. Keep doing better. Always better. And always remember—make it so good they'll have to want it."

In the next 15 years, Disney did just that. We wanted *Peter Pan*, *Lady and the Tramp*, *Sleeping Beauty*, *101 Dalmatians*, *The Sword in the Stone*, *The Jungle Book*.

Walt Disney died on December 15, 1966, less than two years after his most successful integration of animation with live action—the musical comedy *Mary Poppins*, starring Julie Andrews, Dick Van Dyke, and an irrepressible staff of animated penguin waiters.

After Walt died, his studio seemed to lose its storytelling stride—particularly when integrating animation with musical comedy.

The animated characters were rich as ever, but the stories they enacted were not as memorable, particularly for those who thought of Snow White or Sleeping Beauty or the ugly duckling fable of Dumbo as metaphors for their own lives. Only *The Rescuers* had Disney's customary narrative zing.

Then came the disaster of *The Black Cauldron*.

The disaster was that for the first time, no unforgettable characters emerged from a Disney animated feature. The overplotted story left the animators too little time for character development.

In 1984, a new management team took over the direction of the Walt Disney Company. Roy E. Disney, the son of Walt's brother and partner, Roy O. Disney, and a major stockholder in the company, brought in Michael D. Eisner as chairman. Eisner, who had been the head of Paramount Pictures, picked Jeffrey Katzenberg, his chief of production at Paramount, to run the film and television studios as Chairman of the Walt Disney Studios, while Eisner concentrated on the theme parks. Roy E. Disney became the head of animation, and chose Peter Schneider, an executive with a theater background, to be president of feature animation.

Schneider was very clear about what Walt Disney should be doing with its medium as the studio founded in 1923 approached the last decade of the 20th century. He still says it tirelessly to the hundreds of new animators and technicians that he has recruited and trained and molded with those who survived the transition from Disney.

"One, create great characters with definite personalities. Two, give them exciting stories to act out. Three, push the boundaries of animation as an art form and technology with each succeeding picture."

The new era began with an immediate return to solid storytelling. Ron Clements and John Musker, two Disney artists drawn to animation by seeing *Pinocchio* as boys, wrote and co-directed with Burny Mattinson *The Great Mouse Detective* (1986), a funny caricature of the Sherlock Holmes stories acted out by a London mouse. Clements and Musker made sure that the heart of their story was a mythic father-search, and they made little Olivia and her kidnapped toymaker father lovable, and Basil of Baker Street amusingly intrepid, and his loyal Dr. Dawson and dog Toby jolly animated company, and the notorious Professor Ratigan as ruthless a rat as Vincent Price had ever given voice to.

Similarly, *Oliver & Company*, the next animated feature of the new era, was solidly grounded in the Dickens story it caricatured, for it was Oliver Twist with an orphan kitten as Oliver and a pack of dogs as Fabian's gang.

But *The Little Mermaid*, the second feature written and directed by the new team of Clements and Musker, was the storytelling triumph. At its heart was another mythically powerful theme: that we have to learn to give up our children, to let them be free to do what they want to do—to let them make their own mistakes even though we yearn to protect them. The next feature was a sequel, *The Rescuers Down Under*, which attested to the solid storytelling of the original Rescuers tale.

If *Mermaid* heralded a new era for Disney, this renaissance was officially recognized when *Beauty and the Beast* came out.

Beauty was nominated by the Academy of Motion Pictures Arts and Sciences as Best Picture of 1991—the first time that an animated film had ever been nominated for Best Picture. The film won two Oscars: Alan Menken got the award for the best original musical score, and the title song, "Beauty and the Beast," won for Menken and Howard Ashman their second Oscars for best song—"Under the Sea" from *The Little Mermaid* having been the first. Like Clements and Musker, Ashman and Menken knew how to tell a classic fairy tale.

Having accomplished all that, the new generation planned an innovative departure. In *Aladdin*, Disney is taking a chance on a new kind of experimental musical theater—contemporary in its broad, fast-moving humor and topical gags, in its close integration of story, songs and musical score with modern design in color and motion, in its use of cutting edge computer graphics imagery to enhance the animation, in its blithe mixture of curvilinear forms and shapes and strong silhouettes of Islamic achitecture and Persian miniatures, Arabic calligraphy and Erté costume design, with character design influenced by the similarly swooping lines of Al Hirschfeld caricatures that have given the *New York Times* for over sixty-three years images of Broadway stars in pure line, and in its unification of pencil lines and background designs as never before.

The Disney version of *Aladdin* keeps the core of the Thousand Nights tale. But to speak to the same broad audience that made *The Little Mermaid* and *Beauty and the Beast* triumphs in the 1980s and '90s, *Aladdin* operates on two levels: for the child in all of us there is lots of magic, appealing characters, and a new score by Alan Menken, Howard Ashman, who died while *Aladdin* was in production, and Tim Rice, the lyricist who won a global audience by writing "Don't Cry For Me, Argentina." For older people on the symbolic quest for self-realization, the story starts Aladdin out as a bit of a phony who has yet to believe in himself. Moreover, computer-generated imagery enhances the graphics in surprising places—such as the Tiger-God who swallows several of the characters.

Nine new animated personalities compel belief in the same way that the animated personalities of Walt's day did. This book is organized around these major characters. Each chapter is devoted to a particular aspect of animation as illustrated by a character: story, design and direction, sound, layout, animation, color, backgrounds, and special effects.

So you will meet:

Aladdin: a street kid who knows he was meant for bigger things in life. You see from the way he goes after Jasmine that he has the persistence he needs. He's a diamond in the rough who can't give her rubies or emeralds, but has a way of presenting her with an apple he swipes that a Prince couldn't match for charm.

Abu: Aladdin's sidekick, a little capuchin monkey whose pickpocketing tendencies get him into trouble in the story—but whose fundamentally good heart gets him out. You gotta like a guy whose best friend is a monkey.

Princess Jasmine: She's the contemporary Disney heroine—independent, spunky, and determined to follow her heart.

Jasmine has been frustrated by her cloistered life at the palace, and by her overprotective father, the Sultan. That's why she disguises herself, runs out to the marketplace, gets in trouble with a vendor, and creates the situation that Aladdin has to help her out of.

The Genie: a spirit who can transform himself into anything he thinks of as fast as he can free-associate; who loves verbal and visual puns, jokes and jibes and sight gags, flashes of merriment—and freedom.

He is millennia-old, blue in color, and feels an irresistible urge to ridicule tyrants, including:

Jafar, the Wicked Wazir: the treacherous adviser to the Sultan. Jafar is a two-faced sycophant who plots behind the Sultan's back to do away with him, take his place, assume the throne—and marry the Princess.

The Sultan: Jasmine's befuddled, toy-loving father, a benevolent monarch who just wants to see his only child happily married. But he is so guileless that unless he finds someone to advise him to beware of his adviser, he won't live to give toys to his grandchildren.

Of course, Aladdin wants to marry the Princess, too—but in Agrabah only a prince can marry a princess. Aladdin's problem appears to have a solution when he rubs the lamp and meets the Genie.

As in every Disney animated feature, the heroes and heroines have their helpers and harmers, including:

Rajah, pet tiger to the Princess, who comes almost to her shoulders, though she treats him like an overgrown cat. Rajah has a non-speaking role. A growling role.

Iago, Jafar's helper in harm, is a parrot who acts stupid in public—and does it convincingly—but when he and Jafar are alone, he's full of advice.

And finally, in a Disney tradition going back to Dopey, the beardless dwarf in *Snow White and the Seven Dwarfs* who didn't talk, we have a new pantomime character:

Enter (with a flourish of tassels) the flying Magic Carpet: He doesn't speak at all, yet he has that definite personality Walt demanded.

The Genie cracks his knuckles; Aladdin leans down and whispers to the Magic Carpet; Jasmine sings—and we believe. With the split-second synchronization of the actions, words, songs, designs, changes of size, shape, position and color of animated personalities reacting in painted space, Aladdin's creators are inviting audiences to laugh, thrill to beauty—and believe. They are after what Walt Disney was after—speaking the unique language of the animated film so fluently that we believe these characters are alive. For at its heart, this modern Disney animated musical is as personality-driven as *Pinocchio*—or a night at the Palace with Jolson or Garland, Will Rogers or W.C. Fields. And it may be that a future list of great musical comedy stars will have to add this new crowd from the Sultan's Palace—Aladdin, Jasmine, the Genie, Jafar, Iago, Abu, Rajah, the rolypoly Sultan himself—and certainly the Magic Carpet.

So let's take a look at the actual, step-by-step making of a film in this new era, and the creation of nine new Disney personalities.

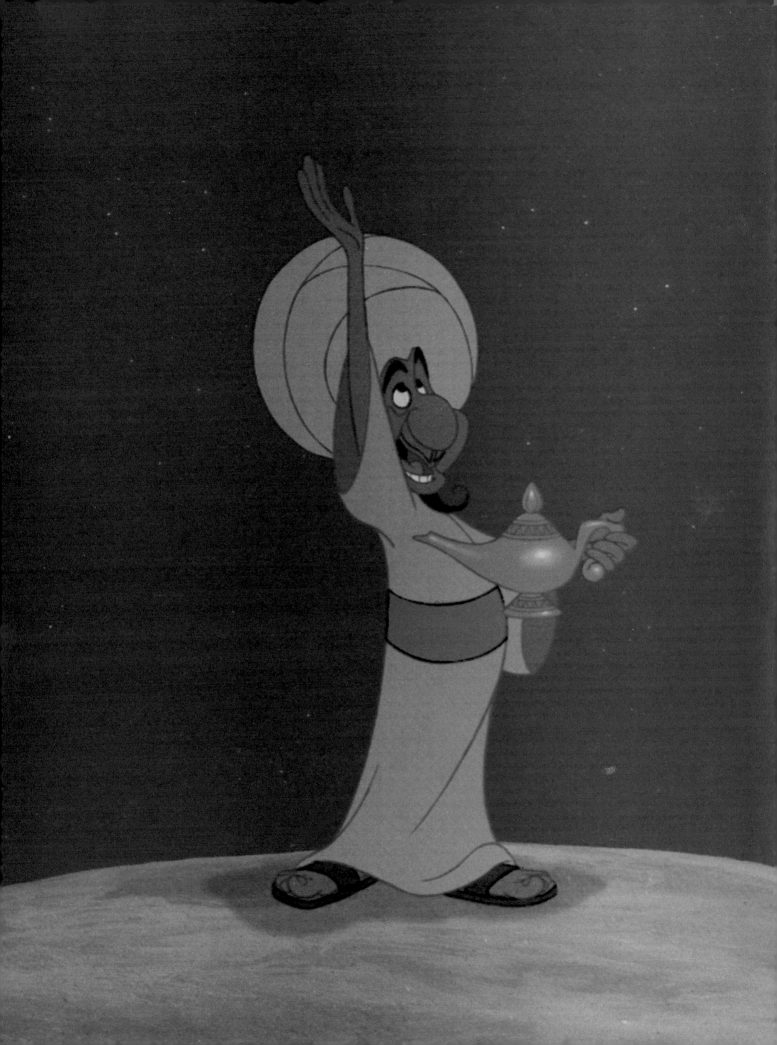

Definite Personalities
Acting Out a Great Story
The Peddler

Disney's best animated films all begin with a simple frame of story. And as soon as we see an old Peddler on the screen in *Aladdin*, and hear him try to sell us a commonplace-looking lamp, we know that the story, like the drawing style, has been streamlined.

"Do not be fooled by its commonplace appearance," says the Peddler, the teller of our tale, of this old lamp. "Like so many things, it is not what is outside but what is inside that counts. This lamp once changed the course of a young man's life. A young man who, himself, was not quite what he seemed."

The Peddler pours stars out of the lamp and into his hands.

"Perhaps you would like to hear the tale. It begins…"

He throws the stars to the sky.

"On a dark night…"

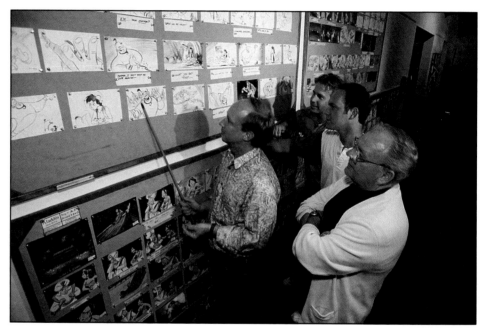

Story supervisor Ed Gombert (with pointer) shows a storyboard that he and Burny Mattinson (right) have drawn to Ted Elliott and Terry Rossio.

Nine sketches from the storyboard show the Peddler begin to narrate the film. "Do not be fooled by its commonplace appearance," he says of the lamp. "Like so many things, it is not what is outside but what is inside that counts"—the number one story point for the whole movie.

The story deals with a young man who finds a magic lamp which, when rubbed, produced a genie who grants the young man's wishes. But in what he wishes for and what happens next, *Aladdin* becomes the oldest kind of love story:

"Boy Meets Girl (Princess Bedrulbudour in Galland's 1717 translation); Boy Loses Girl (the envious Wazir gets the lamp; makes the Genie transport Wazir and Princess to Africa); Boy Gets Girl (first, of course, Boy Has to Get Lamp Back).

But the Disney version contemporizes the tale to:

1. Young Man (Aladdin) Meets Young Woman (Jasmine)

2. Young Man Loses Young Woman—But Proves Himself Worthy, not by using Genie but by Being Himself.

3. Young Woman says: "I choose you, Aladdin."

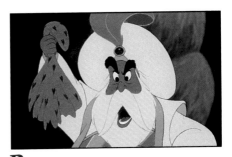

Because a good story sketch explores camera angles, staging, acting, locale, props, and character development, the indignant Sultan holding up Achmed's pants with the seat bitten out is visualized similarly in the final film frame.

When she does that, it makes Jasmine a different kind of Disney heroine from Snow White and the Princess Aurora of *Sleeping Beauty,* who were of interest because of their beauty and good singing voices, and who actually slept right through their rescues by Prince Right.

Jasmine is even more of a go-getter than Cinderella, who did, after all, have the gumption to go to the ball—but whose victory consisted mostly in having the right shoe size.

The ways that the story was changed and the ways that the story was not changed show a lot about the tried and true ways that Disney versions of classic tales are made.

In the original tale, for example, Aladdin sends some jewels the Genie got him to the Sultan by his mother, who asks for the princess in marriage for her son.

"My good woman," says the Sultan, "I will indeed make your son happy by marrying him to the princess as soon as he shall send me forty large basins of gold full of the same kind of jewels you have already presented to me."

Ron Clements and John Musker, the co-writers/directors/producers, eventually eliminated Aladdin's mother from the story, let Aladdin speak for himself, and let the Princess pick her own mate.

"The original story was sort of a winning the lottery kind of thing," Clements explained. "When we got into it, particularly coming in at the end of the

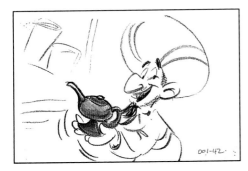

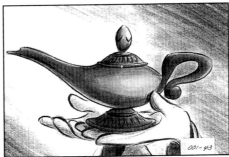

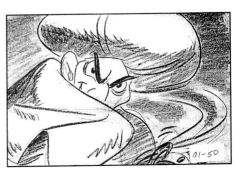

1980s, it seemed like an Eighties 'greed is good' movie." He smiled his shy smile. "Like having anything you could wish for would be about the greatest thing in the world and having that taken away from you is bad, but getting it back is great. We didn't really want that to be the message of the movie. We tried to put a spin on it. Like having anything you could wish for may *seem* like the greatest thing in the world. But things are never quite what they seem."

So why does Jasmine choose Aladdin?

Because Aladdin finally gets smart enough to be himself—not a phony prince.

Making the Princess Jasmine an independent-minded woman "was deliberate," said John Musker, explaining how the idea of making an animated film version of Aladdin got from the idea stage to a story being acted out on the screen by eight principal characters and a whole parade route full of minor ones.

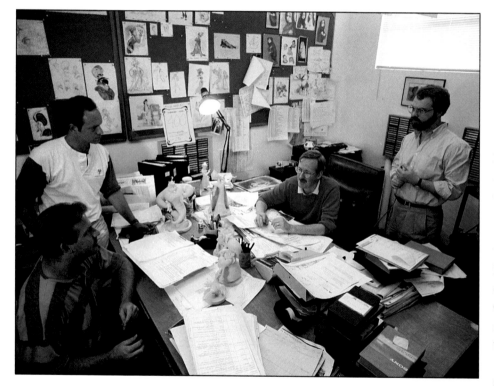

(Left to right) Terry Rossio (seated) and Ted Elliott, who are co-writing the screenplay that will be turned into the storyboards with John Musker (seated) and Ron Clements.

"Jasmine is rebelling against the social structure in choosing to marry someone of her own free will, and rightfully so," said Musker. "We're with her on that one. She should follow her heart and not have to have her life dictated to her in any way by anyone above her or in authority over her. It should be her choice whom she marries."

But why did she choose Aladdin?

"The biggest thing that we started with was the idea that it's not what you have on the outside, but what you are on the inside, that's important," said Clements. "Inner values opposed to superficial values. And that's the thread that runs through the movie."

"Freedom is the biggest theme," said Musker. "The Princess wants her freedom. Everybody in the film is trapped by one thing or another. Aladdin is trapped by his social station. The Genie is trapped in the lamp. Jafar feels trapped because he's got to answer to the Sultan, who he thinks is an idiot. The Sultan is trapped by a stupid law into trying to marry his daughter to someone she doesn't want to marry, and his daughter is trapped by the same law."

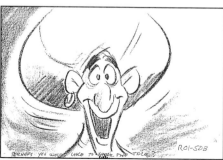

"Aladdin gets the lamp," Clements said, finishing his partner's thought, "and gets, presumably, this thing that's the answer to his problem. But this traps him even more, because he gets trapped into this role-playing of being a prince, which he really is not. And at the end of the movie, everybody is freed from his own trap to some degree—except Jafar."

Clements's initial structure-oriented presentations were "plussed" by colorful details and sight gags by Musker. Both artists share a gift for creating characters with definite personalities to flesh out their stories. Just as Walt Disney's artists surrounded Cinderella with a cat and mice who became Lucifer, Jacques, and Gus-Gus, so did Clements and Musker surround the Little Mermaid with a little yellow-and-blue fish friend named Flounder; an unselfish shellfish called Sebastian (voice by Sam Wright of "The Tap Dance Kid"); a silly seagull named Scuttle (voice by comedian Buddy Hackett); and the evil eels, Flotsam and Jetsam (voice by Paddi Edwards). There was also a flamboyant octopus villainess, the seawitch Ursula, whose contralto growl was supplied by Pat Carroll, fondly remembered by Clements and Musker as Bunny Halper on TV's *The Danny Thomas Show*.

While Clements and Musker were animating the songs that Ashman and Menken had written for *The Little Mermaid*, the songwriting team had begun to write songs for *Aladdin*. To do this, however, Ashman had started by writing a screen treatment of the *Arabian Nights* tale.

Ashman and Menken wrote a full version of *Aladdin* and presented it to Jeffrey Katzenberg. But Katzenberg had another project in mind that he preferred them to work on. He asked them to start writing songs for *Beauty and the Beast*.

"We went ahead with *Beauty and the Beast*," said Menken, "and then we came back to *Aladdin* after that."

"When we finished *Mermaid*," said Ron Clements, "we didn't know what we were going to do next. Jeffrey offered us three projects. One was *Swan Lake*. Another was *King of the Jungle*. The third was *Aladdin*. *Swan Lake* seemed too much like *Mermaid*, which we had just finished, so it was between *King of the Jungle* and *Aladdin*. *Aladdin* seemed like the most fun."

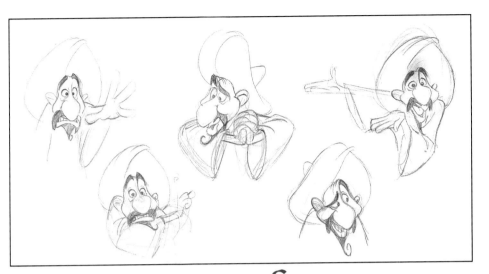

Character design drawings by Duncan Marjoribanks (above and below) explore the personality of the Peddler who will narrate the film and introduce the magic lamp.

In the six story sketches by Ed Gombert below, the artist works on gaining sympathy for Abu, who, like Aladdin, is a thief, by showing both as Arabian Robin Hoods, taking from the rich and giving to the homeless.

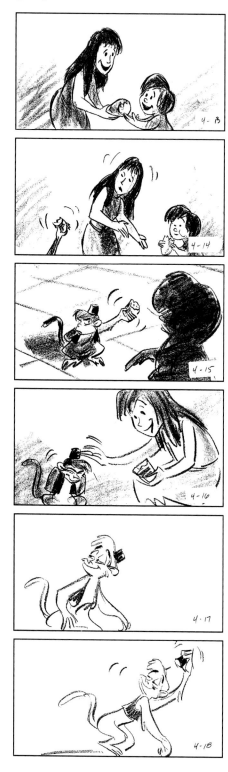

"A lot more fun," said John Musker. "Cartoonier."

"Howard Ashman had turned in a treatment and six songs for a version of *Aladdin* as part of his overall deal with the studio," Clements continued. "He had contracted to do two animation projects and one live-action project, and *Mermaid* was the first animation project and *Aladdin* was the second one. Howard wrote a forty-page treatment, and Jeffrey had a script developed based on Howard's treatment, and then he said to us, 'Don't worry about trying to work Howard's treatment into this. Let's get a story that we like.'"

To Peter Schneider, this sounded very familiar: "Almost all of our movies—*The Little Mermaid* to a lesser extent, but certainly *The Rescuers Down Under, Beauty and the Beast,* and *Aladdin*—about a year and a half before they're released, we throw everything out and we start again."

Story problems are often solved by asking, "Whose story is it, anyway—and why should we care about them?" *Beauty and the Beast* got on track when the story people realized that the Beast was the character with the problem that needed solving. Musker and Clements, in reanalyzing their material, saw that if they didn't get audiences involved with Aladdin as the hero of the story, all the fast-paced comedy with the Genie and the other characters would not give the film the "heart" that makes audiences root for the protagonists of the most successful Disney features. Two screenplay writers helped them to focus on this challenge.

Ted Elliott and Terry Rossio were under contract to Hollywood Pictures, a live-action division of Walt Disney Productions, but they had always had an interest in writing for animation; so when their agent said, "Would you like to work with Ron Clements and John Musker?" they were quick to say yes.

"We had seen both *The Great Mouse Detective* and *The Little Mermaid*, and thought they were terrific," said Rossio. "When you get a chance to work with good directors, it doesn't matter whether it is in animation or live action."

"People talk a lot about collaborative movie-making," said Elliott, "but I haven't seen movie-making as collaborative as animation is—ever. This should probably be how all movies are made. You storyboard out the entire movie, you put it all up on reels, you get the voices recorded—and you can see what the movie is going to look like. It's like opening a play for previews before you take it to Broadway. You get a chance to go in and adjust and fix, to polish the dialogue—and, in some cases, completely rethink the structure."

"There's an attitude in animation," Rossio said: "'How can I make this film better?' The creative vision gets filtered down. Wherever a good idea comes from—as long as it's a good idea—let's use it. I could probably think of at least fifty intelligent, creative, talented people who have thought really hard about this film."

Elliott and Rossio were brought in to help work on the screenplay, which would be turned into storyboards. Veterans Ed Gombert and Burny Mattinson and the staff worked fulltime on the boards.

"Economy is crucial in animation," said Rossio of writing dialogue.

"In a live-action script, you don't mind doing maybe two pages of dialogue, but in animation, that's just not going to fly," said Elliott. "You know that you've always got to remember the visual element. The dialogue is meant to enhance what's going on as opposed to carrying the story itself. When we write the lines, the story-

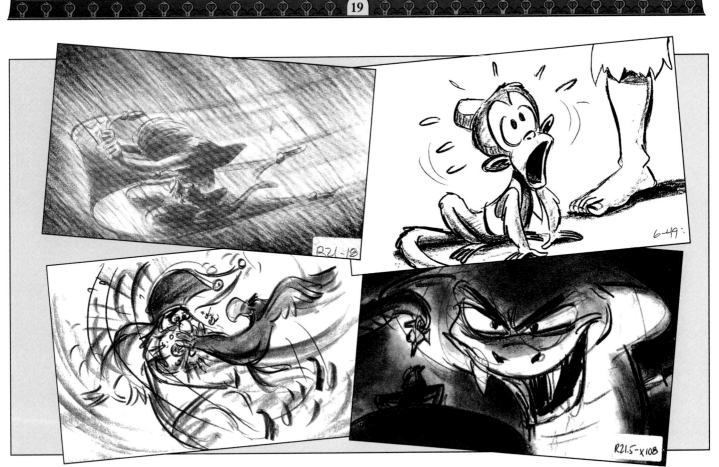

board artists do the pictures. But the storyboard artists are essentially screenwriters, too. And John and Ron would rewrite and change things around. When we got to recording, the actors would add things, improvise, change things around. It was collaboration all the way down the line."

A vital contribution to all Disney collaborations is the element of surprise. John Musker is fond of saying, of all aspects of production, "It has to serve the story"— but he also points out that some things serve the story simply by being entertaining and fun — and surprising.

"You're tickled by the left turns, " he says. "In *Aladdin*, the kind of Genie we've got will be a surprise."

That surprise starts with the Genie's very first appearance.

In the Genie's brand of magic, he can become whatever he talks like—endless transformations beyond the wildest dreams of Rex Ingram's Genie in Alexander Korda's *Thief of Baghdad*.

Musker gives an example: "When we wrote him coming out of the lamp, I think he just said, 'Say, you're a lot shorter than my last master—have you started shaving yet?' Then he went into his, 'What would you wish of me?'"

At the first recording session, however, the voice of the Genie improvised a surreal stream of consciousness that would have delighted Salvador Dali.

"His ad-libbed version—and he did many of them," said Musker of the Genie's voice, turned the Genie, first, into a spirit vain about being ten thousand years older than the last time he was rubbed the right way.

"Say, you're a lot smaller than my last master," he began, as scripted—then dropped the comment about shaving and added: "Either that, or I'm gettin' bigger!"

The storyboard artist is called upon to make the first visualization of anything the directors can imagine, from a Magic Carpet flying though a stormy night sky (top left) to Abu the monkey being dramatic, to Iago the Parrot being offensive (naturally), to Jafar the Wicked Wazir showing Aladdin "how snake-like I can be." (bottom right)

In the Genie's endless transformations, if he can say it, he can be it.

Okay. Easy enough to animate. Eric Goldberg drew the Genie getting bigger and lifting his belly.

"Look at me from the side," begs the vain Genie anxiously. "Do I look different to you?"

Eric Goldberg drew him dropping his belly and turning to the side. This bit was moved further back in the monologue. Now the Genie decides to begin by coming out of the lamp, grabbing the back of his neck, and bleating, "Ten thousand years will give you such a crick in the neck! Hang on a second…"

Animators love to have vocal sounds to animate—sighs, hiccups, snores, gurgles, gasps—and the Genie voice now lets loose with: "Whaaa, wow!! Does it feel good to get out of there! I'm telling you—nice to be back, ladies and gentlemen! Hi, where are you from? What's your name? Aladdin?"

"That wasn't written down for him to say," said Musker. "And the Genie didn't have a microphone. But when we redeveloped visuals on that, Eric Goldberg suggested, 'Let's have him use his tail as a microphone and let's add a Las Vegas–type sign that says Aladdin.'

"The voice of the Genie had ad-libbed, 'A-laddin? Hello, Aladdin. Nice to have you on the show. Can I call you Al? Or maybe just Din. Or how about Laddie? Sounds like, "Here boy!"' The Genie's voice whistled and called, 'Come on, Laddie!'

"After the recording session, we transformed the Genie into a Scotsman on 'Laddie,' with a kilt and a tam.

"And when the Genie whistled for the dog, this Scots Genie became a little Scotsdog in a kilt of the same pattern as the Scotsman had worn."

And so it went, until, at the end of the scene, the Genie had been, in the space of a few dizzy minutes, a pumped-up caricature of Arnold Schwarzenegger, a ventriloquist, a chorus of Genies, a Genie imitating Ed Sullivan and Groucho Marx, an enormous Genie holding in his hand forty thieves who attack Aladdin with forty swords (but he fights them off successfully because, as Howard Ashman wrote in the lyrics to "Friend Like Me," which the Genie had now begun to sing:

> Well, Ali Baba had them forty thieves
> Scheherazade had a thousand tales.
> But master you in luck, 'cause up your sleeves
> You got a brand of magic never fails.

As Musker and Clements and Goldberg collaborated, all the while getting input from all over the studio, most especially from Ed Gombert and storyman Kevin Harkey, the Disney brand of magic got wilder yet. The Genie is, at warp speed, a fight trainer, a Genie-Rocket, a maitre d' ("What will your pleasure be?"), a magician plucking the hat off Aladdin's head and pulling out a rabbit that transforms into a dragon that blows his fiery breath over Aladdin's head (which aforementioned fiery breath turns into three dancing girls to dance with Aladdin), and then becomes a tiny Genie diver diving off Aladdin's hands as off a diving board, and a giant certificate (you had to be there), and a prestidigitator of dancing elephants and camels, and a tornado that scoops up all the magical creatures and sucks back into the lamp; then suddenly reappears as a William F. Buckley

lookalike warning Aladdin that, although he is supposedly owed "any three wishes" he wants, "There are a few...ah...provisos [the famous Buckleyan "ahhhh" here]—a couple of *quid pro quos*..."

"Like?" asks Aladdin.

Imagine! After that fantastic flight of fancy, veteran storymen Musker and Clements now make a perfect three-point landing—three story points, that is—as they have the Genie say:

"Ah, rule number one, I can't kill anybody! So don't ask.

"Rule number two, I can't make anybody fall in love with anybody else."

("A big 'MWA' kiss" is the note that Elliott and Rossio have added to their screenplay, to convey an idea of what the audience would hear on the soundtrack.)

"Oh, you little punim, there!" ad-libs the Genie voice.

(Punim: one of the Jewish terms of endearment from the "It's a Small World After All" vocabulary of the gentile Genie voice.)

"Rule number three, I can't bring people back from the dead! It's not a pretty picture; I don't like doing it."

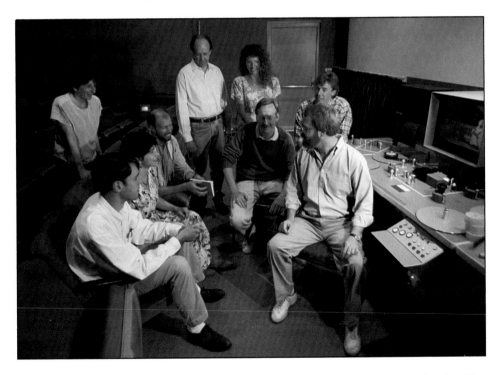

Walt said, "Keep having meetings." Ron Clements, seated at the console in the foreground, comes up with a notion that clearly amuses his partner, John Musker, and Co-producer Amy Pell, standing in the second row. Gathered at 10:45 a.m. on a Tuesday to turn ideas into Aladdin are (seated left to right) Production Designer Richard Vander Wende, Vera Lanpher, head of the cleanup department; Dan Hansen, artistic coordinator; and, standing, H. Lee Peterson, Editor; and Background Supervisor Kathy Altieri. Seated behind Musker and Clements is Art Director Bill Perkins.

And here, Musker and Clements, with their vision of the finished color film dancing in their heads, are already thinking about the color models that Richard Vander Wende can provide for them of the Genie's head turning into a giant pair of lips that will turn into a ghoulish Peter Lorre–type whispering anti–Living Dead sentiments:

"We're going to color model that vaguely Peter Lorre-esque ghoul to look fairly ghastly," enthused Musker. "He's gonna have ooze and stuff dripping off of him—sort of EC Comics stuff."

This is the way that story points are made in a Disney animated feature—by the conference method, by one idea suggesting another.

But it all begins with the simple frame of story.

Design, Direction...Inspiration
The Genie

Eric Goldberg is the animator John Musker calls "head guy on the Genie." "I would like to present one of our directing animators," Musker said, introducing Goldberg to a work-in-progress showing in Manhattan in March of 1992. "He was the first animator on the movie, and he helped sell the whole approach we wanted to take on the Genie."

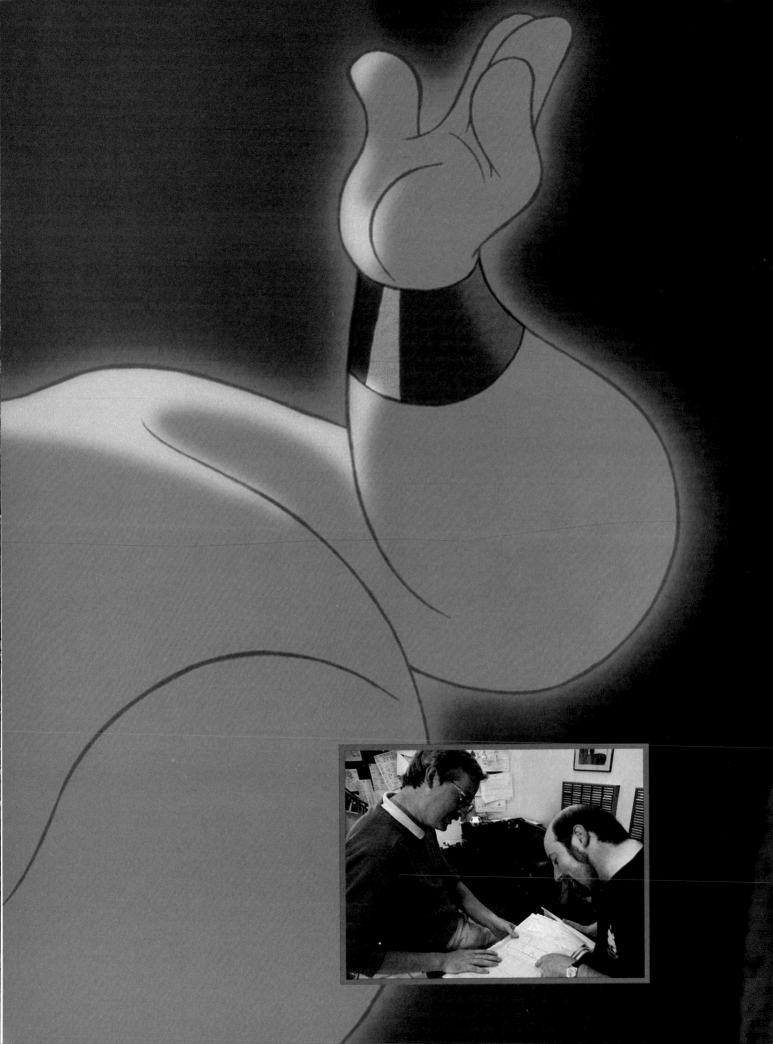

"It was a great coup for us to hire him. This is actually his first film for Disney. His design sense has influenced not only the Genie, but the entire film, and he is absolutely essential."

Eric Goldberg owned an animation studio in London called Pizazz Pictures for six years prior to joining Disney. As a director of animated commercials, he won two Clios. John Musker and Ron Clements wanted Eric Goldberg's kind of thinking for character design and hired him for *Aladdin*.

Goldberg took a swoopingly linear, highly caricatured approach to the characters such as Albert Hirschfeld takes to his caricatures of celebrities in *The New York Times* Arts and Leisure section. Then Richard Vander Wende and Bill Perkins

Eric Goldberg imagines seeing the Genie from an aerial view and that's the way he draws him.

Goldberg found his inspiration for the Genie's design in the strongly silhouetted shapes drawn by the theatrical caricaturist Al Hirschfeld, as in the Maurice Chevalier caricature on the opposite page.

pointed out the connections between Hirschfeld and the S-curves of Arabic calligraphy and Persian miniatures that would unify the characters and backgrounds in *Aladdin*.

Each character was reduced by Vander Wende to a very simple, direct, graphic shape.

"Jasmine's basic shape is an hourglass," said Eric Goldberg. "Every time we see that shape on the screen, that's Jasmine—even in XLS, as the layout man calls his extra long shots. The Sultan's basic shape is an egg. These are very, very simple shapes, so that, wherever you see these characters, they'll 'read' immediately."

Goldberg explained with drawings: "The characters are much more simplified in this film than they have been in previous Disney films. They're still characters. You can still read them and feel them. But what I mean by simplification is that they don't have all the frippery, all the extra construction angles that made them so complicated for animators to draw. Some characters, such as the Genie, you can take more liberties on than others.

"With Gaston in *Beauty and the Beast*, you can see the difficulty in drawing his nose and his cheekbones. There's a lot of attention to academic draftsmanship and accuracy in these types of characters.

"McLeach, the villain from *Rescuers Down Under*, is primarily based on a caricature of George C. Scott, who did the voice, and you still see a certain angularity there.

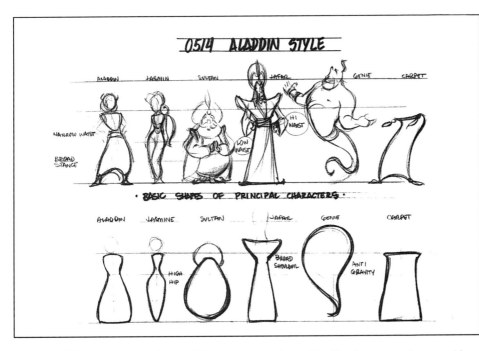

Vander Wende and Perkins found a perfect fit between the Genie's swirling S-shaped silhouette and the swooping lines of Persian miniatures and Arabic calligraphy on which the film's design is based. Soon, strong character shapes abounded.

"We wanted to take a different approach on this film because, for one thing, the tone of the film is very different. It's a 'lighter' film.

"In the preproduction work that was done on the film by Richard Vander Wende, 2-D design elements were combined with 3-D rendering and spatial treatment of light and shadow and reflected light—all done in a very curvy, Hollywood-Arabia style. We wanted the characters to reflect that. So we tended to go toward certain influences to get characters that work in this environment. The first artist I turned to is Al Hirschfeld."

The caricatures of Al Hirschfeld, who turned eighty-nine on June 21, 1992, have adorned the theater section of *The New York Times* for more than sixty-five years. Hirschfeld's gift, like Goldberg's, lies in his ability to capture the essence of personality in the fewest of lines.

"We can see the kind of clarity and simplicity of lines that Hirschfeld gets in his shapes, even though these are very expressive forms," said Goldberg. "Another thing that Hirschfeld is great for is the strength of his poses. They are very readable from a long, long distance away. They have a great deal of elegance from one line leading organically to the next. And there are a lot of dynamics in the poses."

Besides Hirschfeld, the other great influence on Goldberg's designs, he said, "has been Disney's animation history itself."

Goldberg particularly studied the work of "a great animator, Freddy Moore," who, with Bill Tytla, were the Supervising Animators of the Seven Dwarfs, after they redesigned the original designs of Albert Hurter. Tytla told me that he and Moore found Hurter's dwarfs "too dour and Germanic."

Goldberg learned from the fluidity of Moore's animation of Mickey Mouse in *The Brave Little Tailor* (1938) and *The Nifty Nineties* (1941).

"You can see this fluidity happening in the same kinds of shapes that Moore is using in these kinds of poses," Goldberg began—then broke out in a grin: "Not to mention that they're a lot of fun to draw.

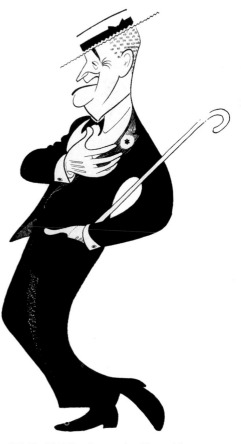

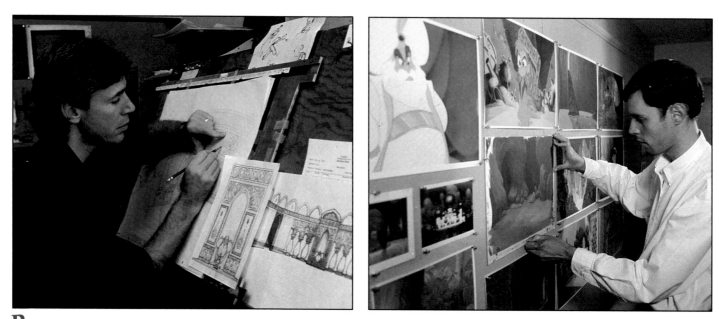

Bill Perkins (top, left) renders the Sultan's throne room with architectural exactness. Richard Vander Wende (right) provided the film with an expressionistic palette in which color changes in the backgrounds support the emotional changes in the characters and story. Color is an integral element of Aladdin's structure, as important as movement or sound.

"To simplify forms to their organic shapes tends to give the animators a lot of freedom in draftsmanship, so they can make their performances that much richer and expressive," he said.

Both "the great art" of the living line and the "unity of figures and background" that Hirschfeld found in the early Mickey Mouse cartoons, Goldberg wanted to bring back.

In both these quests, he found himself in basic agreement with Richard Vander Wende, Bill Perkins, and Kathy Altieri, the triumvirate who speak for the look of the backgrounds, as Musker, Clements, and Goldberg, and the other supervising animators speak for the figures. Together, they are striving for a unity of graphic design rare in a Disney feature.

"Not only are we going to use curvy, organic shapes in this film," said Goldberg, "but also the element of graphic design itself in the characters is very important. We made sure that each of those main characters could be reduced to a very simple, direct, graphic shape. Jafar's basic shape is a box with a guy in it.

"The Genie is basically a trail of smoke. As a sample of the kind of freedom we have in the forms, if I make a happy, smiling Genie, I might decide to give him very accentuated cheeks, so that we can see the expressiveness of his smile. And if I wanted to show the Genie in a surprised mode, nothing would stop us"—Goldberg raised his own cheeks in a grin—"unless it was John and Ron, from dropping the Genie's cheeks entirely in order to go for the most direct kind of hilarious expression that we can get on the character."

The actor signed to play the Genie improvised wildly—to the delight even of Musker and Clements, who had written the script.

"We actually wrote a few of the Genie's lines," said Musker, and everyone laughed. "We started with a script. When we worked with Shakespeare on the first

scene, he did literally twenty-five takes—of which the first eight were scripted. In the other uh…"

He did the math in his head to more laughter.

"...uh, seventeen, we would take the structure of the scene, and he would kind of wing it. Then we would have to reconstruct the scene—and Eric Goldberg was instrumental in this. He, Ron Clements, and I would sit in a room with hours and hours of tape, and say, 'Okay—let's boil it down to the funniest stuff, and then let's see how we can reconstruct it with the new, funny, clean stuff.' I mean, there were some jokes that couldn't quite make it into the movie."

Eric Goldberg's approach to animating the Genie draws much from his study of the animation of Fred Moore, a master of appealing designs whose movement had a natural flow, as when Moore animated Mickey as The Brave Little Tailor in 1938 (above).

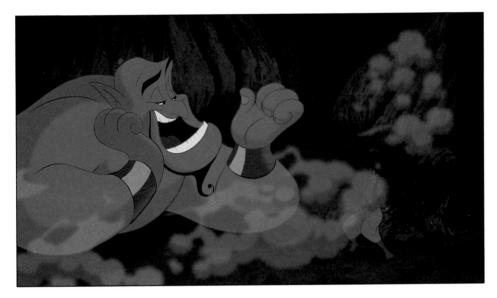

The Genie talks to Aladdin in the Cave of Wonders between transformations requiring smoke effects from Don Paul's visual effects department.

With character designs that animate much more expressively than, say, the princess in *Snow White*, we have seen steadily "the advance…in artistry and extension of range" that Sir David Low, the great British caricaturist and political cartoonist, found in Disney's early features. "They reveal growing understanding of the meaning of observed movement and therefore greatly increased powers of creating imagined movement," Low wrote in 1942. "Compare the play of human expression in the face of Snow White with that in the faces of the Centaurettes in *Fantasia*, and mark the striking improvement. Subtlety is now possible."

Animation had gotten very much subtler in the fifty-two years since *Fantasia* and *Pinocchio*. Much of the reason for this is that Disney animation consciously builds on its own tradition. Ron Clements and John Musker, for example, have both watched the whole development of feature animation from the beginning.

Here and on the opposite page are three developmental sketches for the Genie. "I was the first animator on the film," says Eric Goldberg. "I was drafted in September 1990, I was on preproduction for close to a year, and I designed him, basically, as a swirl of smoke with a nose and eyes."

In Sioux City, Iowa, where he was born and raised, Ron Clements saw *Pinocchio* at the age of ten, and knew that he wanted to be a Disney animator. As a teenager, he began making his own super-8 animated films, including a 15-minute short that he animated all by himself, called *Shades of Sherlock Holmes*.

Sherlock Holmes led to a part-time job as an artist at a television station animating commercials for the local market.

After high school, Clements went to California to make his dream of animating for Disney come true. But there weren't any openings at Disney, so he took a job at Hanna Barbera and studied life drawing in the evenings at Art Center.

He kept knocking at Disney's door, however, and his persistence eventually paid off. Impressed that the self-taught animator had actually made a fifteen-minute animated film, and confident that his talent and capacity for hard work would make up for his lack of formal training, Disney's training committee accepted Clements into their talent development program. His progress there brought him a two-year apprenticeship under Frank Thomas, a key member of Walt's Nine Old Men who was studied for his "sincere" approach to animation.

Under Thomas's tutelage, Clements progressed through the ranks from in-betweener to assistant to animator/storyman. He got screen credit on *Winnie-the-Pooh and Tigger Too*, *The Rescuers*, *Pete's Dragon*, *The Fox and the Hound*, and *The Black Cauldron*.

Clements also gave Frank Thomas the key to his own approach to animation in a comment he made that Thomas and Ollie Johnston later put in their book, *Disney Animation: The Illusion of Life*:

"The greatest challenge in animation is to create a relationship of characters through a picture that an audience believes in. To them, these characters exist—they're real. It's tough enough to create one character that lives, but to get two or more interrelating—that is the impossible dream."

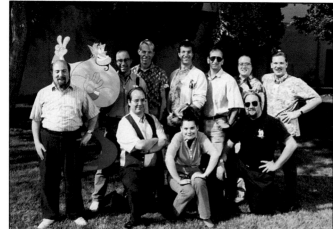

The Genie Animation Crew: Bottom left to right: Raul Garcia, Gilda Palinginis, Tom Sito. Top left to right: Eric Goldberg, Genie, Rej Bourdages, Dave Burgess, Dave Zaboski, Joe Haidar, Henry Sato, Broose Johnson.

Three Faces of Eve? Forget It! Here's Seventeen Faces of Genie. Eat your heart out, Eve!

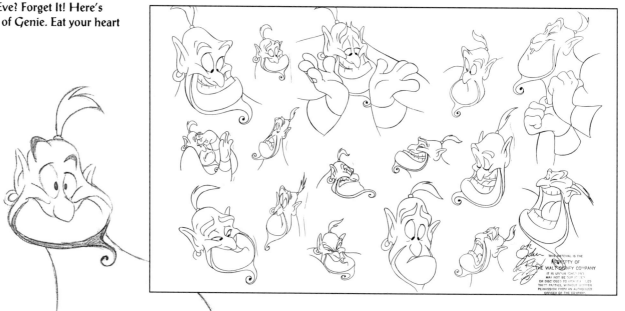

Clements's subsequent career has been in quest of that "impossible dream"—rich interrelationships of the characters in an animated film.

John Musker, born in Chicago, was also inspired by *Pinocchio*; also began drawing in grammar school. At Loyola Academy, a Jesuit high school in Wilmette, Illinois, Musker became a cartoonist for the school paper.

Influenced by comics, cartoons, and the caricatures of *Mad* magazine, he developed a gift for caricature, and his outrageous sketches of teachers and fellow students in high school led him to draw cartoons for the *Daily Northwestern* at Northwestern University in Evanston, Illinois, where he majored in English.

raduating in 1974, Musker took his portfolio to California, where, like Clements, he applied to and was at first rejected by Walt Disney Studios. Never mind: he won a partial scholarship to CalArts to master his craft.

After one year at CalArts, which included a summer internship at Disney, he was offered a full-time job as an animator. This time, Musker turned Disney down, opting instead to complete the second year of his training at CalArts.

In 1977, his two training tests convinced the same talent development program that accepted Ron Clements. Musker began as an assistant animator on the featurette, *The Small One*, then animated on *The Fox and the Hound*, and was one of no less than sixteen story "cooks" assigned to the *Black Cauldron* stew.

Five years before *Cauldron* failed, however, Clements was trying to launch an idea of his own. His teenage *Sherlock Holmes* animation inspired him to want to adapt Eve Titus's book, *Basil of Baker Street*. Clements was teamed with Musker, and, starting in 1980, I used to visit them in their story room as they worked on storyboards between other assignments.

Clements and Musker worked, off and on, for about four years just on the story of a whole new London mouse-world, in which *Basil of Baker Street* is the master sleuth that Sherlock Holmes is in Conan Doyle's imaginery human London. But they could never get the green light for the project to go into animation.

When the new management team of Eisner, Katzenberg, Roy Disney, and Peter Schneider took over, Clements and Musker showed them a tale already illus-

Ron Clements (above) and John Musker divide up the direction of Aladdin's 28 sequences between them. A Musker sequence introduced the Genie but Clements got to direct his freedom—of which such an imaginative role-player (see three roles below) will surely take sublime advantage.

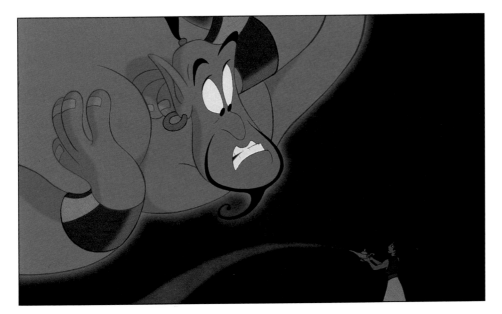

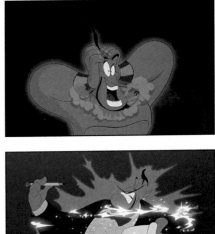

trated by story sketches of two mice who live beneath Sherlock Holmes's London flat and follow in the giant footsteps of Holmes and Watson. Eisner and Katzenberg did quickly what their predecessors had not done in five years: they critiqued the story, changed some things, but gave it the go-ahead to be animated.

That was in 1984. On July 2, 1986, Walt Disney Pictures premiered The *Great Mouse Detective*, its twenty-sixth animated feature in forty-nine years but only its seventh in the nearly twenty years since Walt Disney died.

It worked. The personalities came to life on the screen—and they interrelated. They told a little fable in Walt's way: "Good and evil, the antagonists of all great drama in some guise, must be believably personalized," Walt used to say. "The moral ideals common to all humanity must be upheld. The victories must not be too easy. Strife to test valor is still and always will be the basic ingredient of the animated tale as of all screen entertainments."

Disney had regained its stride. As *The Great Mouse Detective* was delighting audiences around the world, and a second Disney animation unit was preparing *Oliver & Company*, an animated musical version of Charles Dickens' *Oliver Twist*, which presented Dickens' boy, Oliver, as an orphan kitten involved with a gang of dogs in up-to-date New York.

usker and Clements, meanwhile, were planning the feature to come after that. Indeed, Ron Clements had begun searching for a new project when *Mouse Detective* was still a year from its premiere. Clements found an idea he liked in a bookstore, where serendipity seemed to lead his hand to a copy of the fairy tales of Hans Christian Andersen, and his eyes to the story in that volume of *The Little Mermaid*. Visions of undersea fantasy to rival *Pinocchio*'s Monstro the Whale undersea sequence danced in his head.

"I thought it was a beautiful and poetic story with really exciting visual opportunities," said Clements. "It was so cinematic, the images seemed to leap off the page. I also thought it was one of the saddest stories ever written."

Clements wrote a two-page treatment in 1985, which he presented to Katzenberg and Roy Disney. They asked for a longer version of his version of the story, and Clements joined with John Musker in expanding the treatment to twenty pages.

"The biggest problem was with Andersen's ending where the mermaid sacrifices herself and turns into a sea foam spirit when her love is unrequited," Clements explained. "We knew we needed a happier ending to really make it work for our purposes. We tried to come up with a way of doing that and somehow still remaining faithful to the basic themes of the story. We wanted an ending that retains the bittersweet quality of the original, yet is uplifting at the same time."

In the Clements-Musker version, Andersen's unnamed seawitch became the villain and was given a greater role to play in the story. Personalities for Triton, the Little Mermaid's father, and the prince she falls in love with began to take shape. Characters to be helpers for the mermaid were created: Sebastian, King Triton's crab counselor; Flounder the fish; and Scuttle, the seagull.

With Clements and Musker's treatment for *Mermaid* in hand, lyricist Howard Ashman and composer Alan Menken began writing the music.

"Howard and Alan brought a theatrical approach and style to the project that we tried to wed with animation and film technique," said Musker. "The songs were

Musker and Clements first collaborated in the writing, producing, and directing of The Great Mouse Detective. Its success won them backing for The Little Mermaid, at the time the most profitable animated film on its first release in film history. After Mermaid, they had their pick of projects.

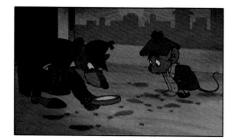

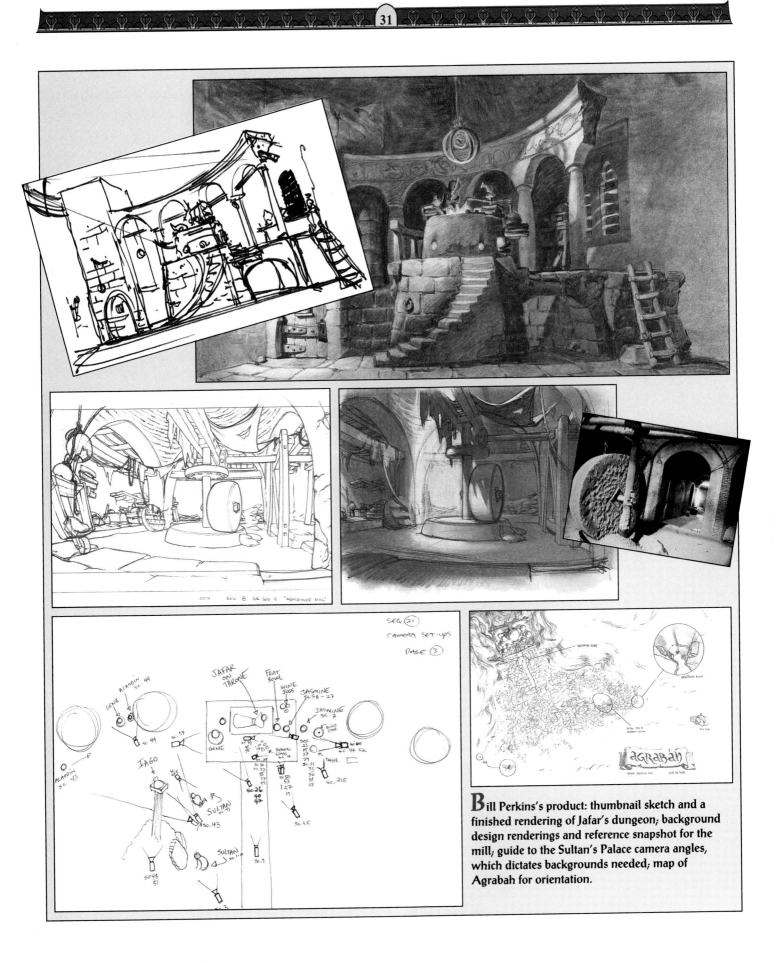

Bill Perkins's product: thumbnail sketch and a finished rendering of Jafar's dungeon; background design renderings and reference snapshot for the mill; guide to the Sultan's Palace camera angles, which dictates backgrounds needed; map of Agrabah for orientation.

On two 11" by 17" sheets of paper, Bill Perkins gets the rest of Aladdin's production team to think about line and light and shadow.

better integrated here than in any Disney film for a long, long time."

The Little Mermaid was, in fact, a throwback to the close story-song integration that Jerome Kern and Oscar Hammerstein II achieved in the classic *Show Boat* in 1927, and that Kern praised in Disney's animated shorts as long ago as 1936. The Disney features carried this integration to new levels of complexity, climaxing in the hand-in-glove scoring by the Sherman Brothers of *Mary Poppins*; but that approach was lost between Walt's death and *The Little Mermaid*. Disney found it again in the work of Ashman and Menken.

"Coming from a musical theater background," said Ashman, "we're used to writing songs for characters in situations. For *The Little Mermaid*, we wanted songs that would really move the story forward and keep things driving ahead. Instead of stopping to sing a song, it's more like you get to a certain point where the crab has to convince the mermaid not to go up above the water and change her life—so he sings 'Under the Sea.'"

During a period of eighteen months, Ashman and Menken wrote and fine-tuned seven songs. During that period, the songwriters set up a music studio at Disney's animation facility in Glendale, where Ashman spent at least two weeks out of every month.

The screen credits would eventually read: "Written and Directed by John Musker and Ron Clements. Produced by Howard Ashman and John Musker. Original Score by Alan Menken. Songs by Howard Ashman and Alan Menken."

When the box-office receipts for *The Little Mermaid* exceeded those of any other animated feature in history on its first release—over $80 million—it was obvious that Clements and Musker were a writing-directing team with a great future in animation. Musker attributed their successful partnership to the fact that "we're both relatively agreeable Midwestern types and we each have slightly different strengths and approaches."

The Clements-Musker approach is marked by a strong emphasis not only on personality animation but on the relationships between—or even among—animated personalities. We can see such a relationship happening on the screen in Sequence 18, scenes 35 through 40—the showdown between the Genie and Aladdin, as animated by Eric Goldberg and Glen Keane. In scene 38, Goldberg gives us a privileged peek into the Genie's heart. It is a close-up that lasts 164 frames—almost seven seconds—a long time in animation; long enough for everyone to glimpse the Genie with his guard down; for, typically, he will quickly make a joke of his hurt.

Aladdin has just told him, "I can't wish you free." Now the young human tries to explain to the old spirit why he is going back on his word. "Look, I'm sorry," says Aladdin. "I really am. But they want to make me Sultan. Nooo, they want to make Prince Ali Sultan. Without you, I'm just Aladdin."

"Al, you won," the Genie replies—but Aladdin knows his "victory" is a fake. "The reason anyone thinks I'm worth anything is because of you. What if they find out the truth? What if Jasmine finds out? I'd lose her. Genie, I need you." Glen Keane animated Aladdin as a young man struggling to convince not only the Genie, but himself that he "can't" wish him free.

Now Ron Clements, as Sequence Director, gives the stage to Eric Goldberg to make, with the Genie's kidding-on-the-square response, one of the film's most important story points:

"Fine, I understand," the Genie replies. "After all, you've lied to everyone else. Hey, I was beginning to feel left out."

When Aladdin lets his friend down, Keane shows us that he can't keep his guilt and shame from showing. Now Goldberg doesn't let the Genie keep us from seeing the hurt and disappointment of a spirit longing to be free. He's millennia too old to cry, but it hurts too much to laugh, and suddenly you remember that his fellow creature in pain is really only... Hey, the directors have used a design in motion to make us imagine the pain of being trapped; the pleasure of being free. They have used the magic of animation to make us empathize with a spirit! And that's what it's all about.

Throughout the production of Aladdin, the unfinished film was shown as a work-in-progress to various audiences. When a fifth-grade class from a nearby school was brought in on a bus with a notably friendly driver and given milk and cookies as well as a show, the thank-you letters included this one from a young viewer who found the Genie true blue.

Comic Genie-us

Anything this bug-eyed Genie (left) can say, he can be; and below, he wants to be a Genie Ed Sullivan, putting on a "really big shew."

Transformations are the strong suit of animation. Because animated films are made frame by frame, the animator controls the projection of the image on a screen down to one-twenty-fourth of a second—faster than the human eye can see the change from one image to the next. Combine that human persistence of vision with the sense of humor of the Genie's animators—and you get Comic Genie-us.

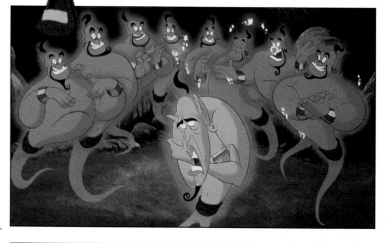

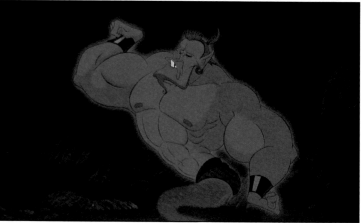

Above, he gets really pumped up—the Arnold Schwarzenegger of Genies; at the left, with a mike, he announces the Thanksgiving Day Parade (far left); below that, top to bottom, he's Groucho Genie and Genie Duck supplying the missing word.

Below: Genie game show host; with William F. Buckley accent; with Jack Nicholson eyebrows.

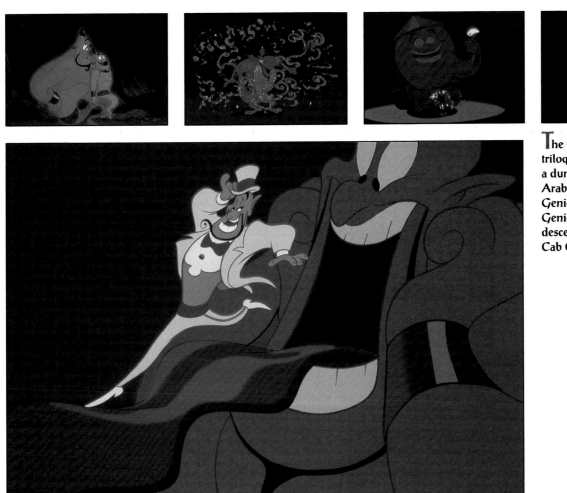

The Genie can become a ventriloquist and throw his voice to a dummy Genie; a dragon with Arabic calligraphy swirls; then a Genie whistle, a slot machine Genie, a Hi-Dee-Ho Genie that descends his own tongue à la Cab Calloway.

The Genie in a rare public appearance as himself (left) and as a character in this film directed by Musker and Clements being bitten by Sebastian the crab from their earlier, undersea hit, The Little Mermaid— a Genie in-joke.

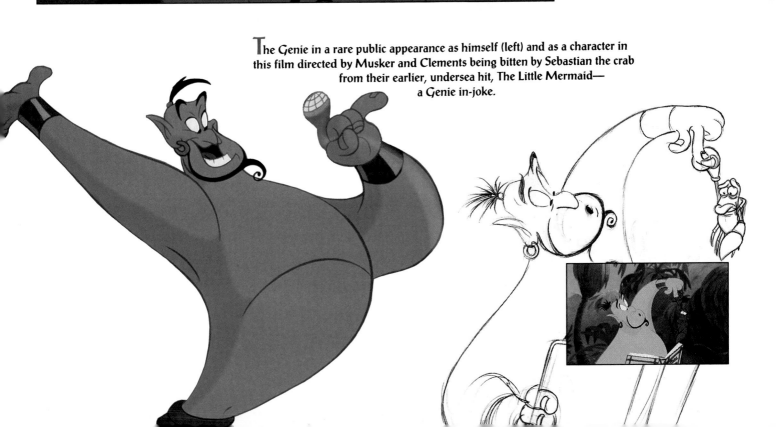

The Sound of Determination
Jasmine

"I love
the voices of the women in
the Disney films,"
said Linda Larkin, who was chosen to
be the speaking voice of
the Princess Jasmine in *Aladdin*.
"To be a Disney heroine—
it's all so magical," she said wonderingly,
as if she wanted to pinch
herself to make sure that it was really
she who was now such a voice.

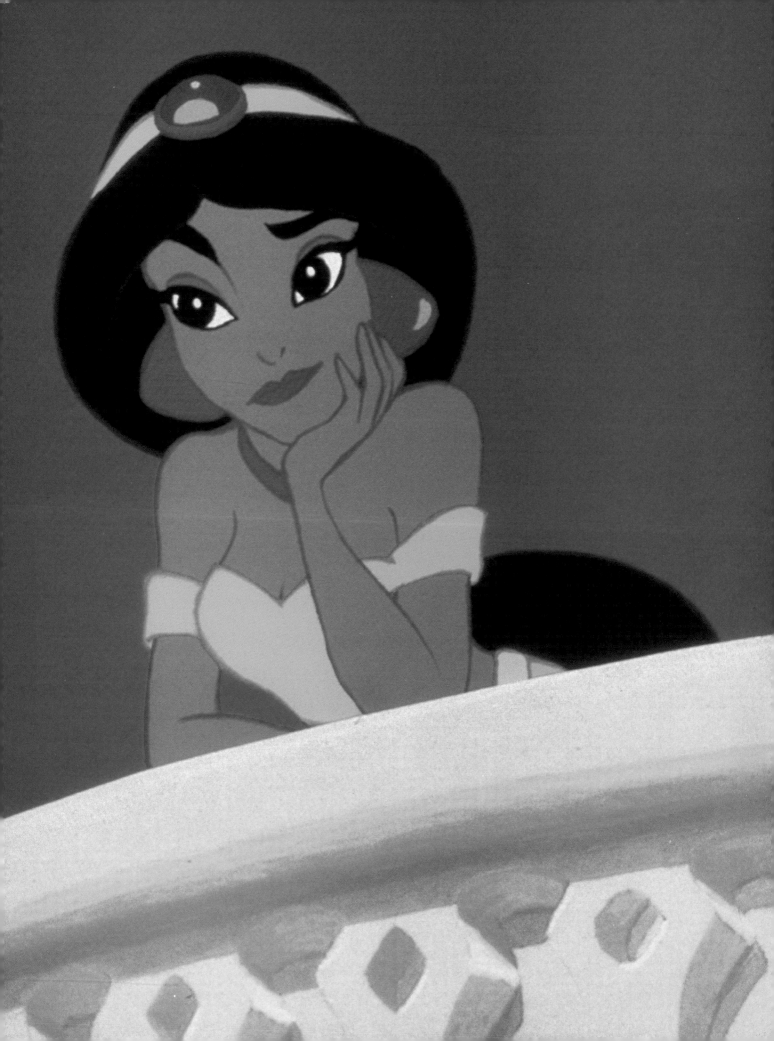

"When I was a little girl in Duluth, I always used to imitate those voices. I used to pretend that I was Snow White—I had this little read-along book."

Her voice, which somehow reminded me of those glass arrangements that hang from front porches to play in the summer breeze, sounded its delight.

"You know what is so great? I just recorded the voice of Jasmine for the read-along book on *Aladdin*! We just finished the session. It brought back so many memories. I used to sit in my room—I was an only child, and I'd sit in my room with my stack of Disney books, and my forty-five-rpm records, and I'd play them and read along and pretend I was Snow White and Cinderella and Sleeping Beauty."

She suddenly remembered to lower the register on her beguilingly enthusiastic voice so that she sounded more Jasmine-like as she concluded:

"They were my heroines."

To follow Linda Larkin from first audition to the voice that seems to speak from the screen with a pink cartoon tongue is to glimpse a bewitching part of the continuing development of what the American composer Jerome Kern heard more than fifty-five years ago as a new language: the perfectly controlled co-expressibility of sound and animated images.

By learning to speak this new language, the girl born in Duluth, Minnesota, on July 18, 1966 ("fifteen minutes from where Jessica Lange grew up"), to a grocer named John Keuhnow, and his wife, Bonnie, now divorced, has been reborn as the Princess Jasmine of Agrabah, a timeless creation inspired by *The Thousand Nights and One Night* (only a flying carpet ride away from the River Nile or the Forbidden City—or Neverland).

Linda had grown up with the old Beach Boys "Surf's Up" song about "fantasy worlds and Disney girls," and redefined herself as a Disney girl, just as she changed her last name to Larkin after family friends who owned the Larkin Dance Studio.

Now Linda Larkin sat in the restaurant on the Disney lot in Burbank, at a table not far from the table in the corner where Walt Disney always sat, and she talked of her dreams back in Minnesota, and the way they came true.

"I went to the first audition for Jasmine with one of my best friends," she began. "We have the same manager, and I remember that she picked up the 'sides' for me—the pages that we had to read at the audition. Then we drove there together. I didn't even look at the sides until I got in the car. I was reading them on the way and I got to the part where I had to say, 'It's all so magical!'—and suddenly, at that moment, I knew!

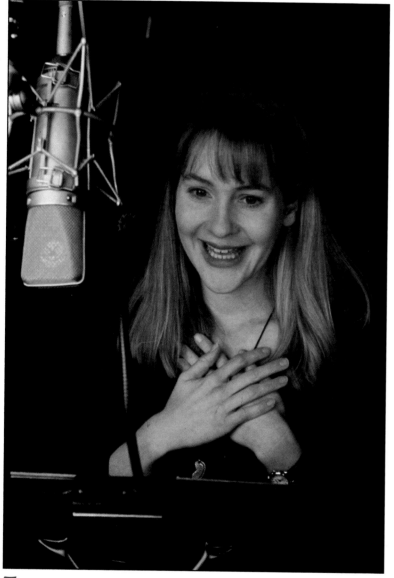

The Princess Jasmine, Aladdin's heroine in the new Disney tradition of liberated young women, gets much of her determination, as well as her sincerity and enthusiasm, from her speaking voice, Linda Larkin (above).

"I was very taken by that line. I got very emotional. I knew this was going to be something for me. After I had auditioned for and got the part of Jasmine, I was down in Florida shooting a pilot for a television show, and Don Ernst, the co-producer of *Aladdin*, arranged for me to go to the Disney-MGM Studios at Walt Disney World and meet Mark Henn, who would animate Jasmine.

"At the time, Mark was finishing up *Beauty and the Beast*, for which he animated Belle, and he took me on a tour of the working animation studio there. The public is allowed to watch the animators actually working at the studio—you know, watch them actually making the drawings that will seem to move on the screen. The tours watch through soundproof glass, but I went to Mark's animation room. I had never seen how it was done before. Mark showed me scenes from *Beauty and the Beast*—his rough animation in pencil, in black-and-white tests, and some finished scenes in color. I sat in that room and I watched this unfinished segment of the movie and it brought tears to my eyes, it was so beautiful!

The supervising animator of Jasmine is Mark Henn, who also animated heroines Ariel, the Little Mermaid, and Belle in *Beauty and the Beast*. Henn designed Jasmine after his sister, Beth, whose picture is attached to his drawing board.

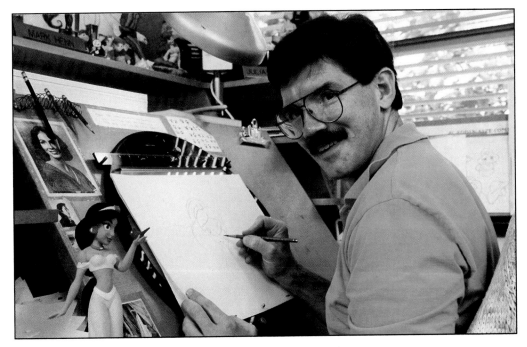

"Then Mark and I went to dinner on the Disney-MGM lot, and he told me the whole story from beginning to end, the whole *Beauty and the Beast*. And the way it captured him captured me as well. Do you know, this man has known since he was seven years old that he was going to be an animator for Disney! Since he first saw *Cinderella* at seven, he has wanted to work for Disney! And I could see the magic in him when he told me the story of *Beauty and the Beast*. And I knew how those characters that he drew came so alive: they were so enlivened by him because he was so enlivened by them.

"And he said to me, 'Jasmine will be a little bit of you; a little bit of me, and a little bit of Robina Ritchie, the live-action model who will come in and pantomime the action to your voice so that the animator gets a feeling of what the real human movement would be.' There's one song for the Princess in the movie, but luckily for me, they didn't have that song when they first cast the character; otherwise it might not be me doing the speaking voice. I'm not a singer. Lea Salonga sings the song for Jasmine. It's called 'A Whole New World.' I say Jasmine's lines.

"Mark said the character should be a combination of all of us."

Down in Florida, many months after that visit, Mark Henn pressed a "play" button.

"It's all so magical," said Linda Larkin's voice on a tape recording that played through the speaker of the same twelve-year-old black-and-silver

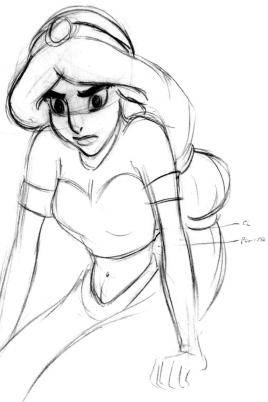

Panasonic tape player and AM-FM radio that Henn brought to his room in the working animation studio at the Disney-MGM Studios when he relocated to Florida three years ago. He and Glen Keane had animated Ariel for *The Little Mermaid* in California. Then Mark moved to the new Disney animation studio at Walt Disney World near Orlando, Florida, and animated Belle in *Beauty and the Beast*. Now he

Right: Lea Salonga and Brad Kane are the singing voices of Jasmine and Aladdin when they take a Magic Carpet ride around the world and sing "A Whole New World," a love duet written for the film by composer Alan Menken and lyricist Tim Rice.

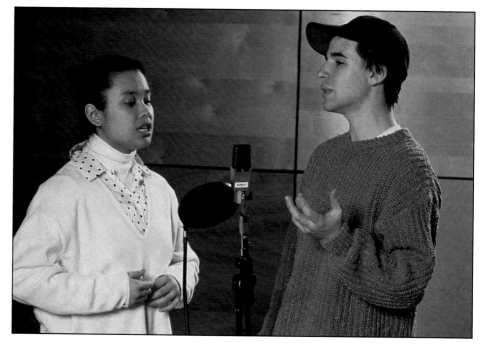

was animating his third Disney heroine, Jasmine, the Arabian princess of *Aladdin*. He was afraid of getting typecast, because it is generally acknowledged at Disney, as one animator said, that "Mark has a way with women—a very graphic way with women."

Henn, too, saw a Midwestern American teenager in his mind's eye as he animated Jasmine saying, "It's all so magical!" with quick strokes of his pencil—but it was not Linda Larkin.

In his mind's eye Mark could see himself and both his sisters marching along together with the Trotwood-Madison high school marching band, in Dayton, Ohio, on Memorial Day, 1976, in celebration of the Bicentennial of the United States of America. They were playing Julia Ward Howe's "The Battle Hymn of the Republic." Mark, the high school senior, played the cornet; Cindy, the sophomore, played the clarinet; and Beth, only a freshman, tootled the flute. It wasn't the first time he had thought of his sisters in animating a scene, Mark said. "Sherri Stoner, the model for Ariel, brought some wonderful physical gestures to the Little Mermaid. One of them was her habit of biting her bottom lip when she was intent on something. I used that, and the gesture made her personality real for a lot of people.

"So with Paige O'Hara, who spoke and sang for Belle, I was looking for a physical trademark for her personality, and one thing that struck me was the lock of hair that—no matter how much hairspray she uses—just won't stay in place. So Paige just had an unconscious habit of continually brushing her hair out of her face.

"As I grew up with two sisters, and certainly observed them fixing or adjusting their hair, it seemed true-to-Belle to me to have her do that.

"Then, on *Aladdin*, I was trying to develop the physical design of Jasmine by looking at photographs of girls in magazines when I suddenly reached in my wallet and pulled out my sister Beth's high school graduation picture.

"It was faded—I have carried it in my wallet for thirteen years—but I looked at my dark-haired sister and I thought, 'Gosh, Jasmine is about high school age and has dark hair.'

"Our original plot line for *Aladdin* had the Sultan saying, 'Jasmine, the law says you must be married by your sixteenth birthday.' That was the original story concept and it stayed for quite a while. Then Jeffrey started to worry about what kind of a message we would be sending all the fifteen-year-olds in the world—that it's okay to get married before your sixteenth birthday? Of course, *Aladdin* is a fairy tale and presumably happened a long time ago, but he thought it would be better to change the line to, 'married to a prince by your next birthday.'

"We added 'a prince' as well, because Jeffrey is usually pretty strong about, 'We've got to spell out what the situation is.' So we made it very clear that Jasmine has to be married by her next birthday—whichever birthday it is—and to a prince.

"See, doing it this way sets it up for the Sultan to say, in the last sequence, 'It's the law that's the problem. What we need is a new law… Well, am I Sultan or am I Sultan? From this day forth the Princess may marry whomever she deems worthy.'"

Saying it with music is one of the primary ways in which Clements and Musker have adapted old fairy tales to communicate with modern audiences. They made the Little Mermaid a singing sea creature who gives her voice to a witch in order to be with her human Prince Charming; and now they wanted the Genie to sing of his friendship for Aladdin, and Aladdin and the Sultan's daughter to sing as they fall in love.

The Little Mermaid was the most popular animated film from the Disney Studio in years, and

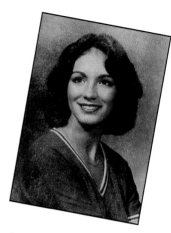

Mark Henn's sister Beth, who inspired Jasmine, in her graduation photo from Trotwood-Madison High School in Dayton, Ohio. Mark stored gestures of sisters Beth and Cindy in his memory bank, and uses them in animating Disney heroines. Aaron Blaise, supervising animator of Rajah, Jasmine's pet, used a three-dimensional maquette as an aid in making the animation drawing of the tiger that became the finished frame.

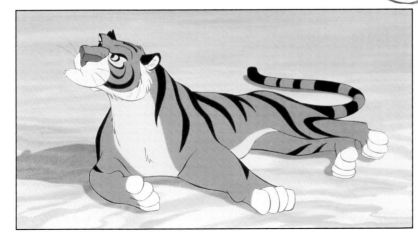

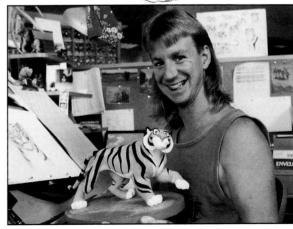

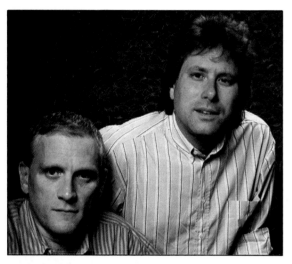

Above, left to right: Howard Ashman and Alan Menken were brought to Disney to write the score for The Little Mermaid, which won the Oscar for Best Song for "Under the Sea." They went on to write the Oscar-winning score and title song for Beauty and the Beast, and wrote three songs for Aladdin before Ashman's death. Tim Rice (below), lyricist of Jesus Christ Superstar and Evita (including the international hit "Don't Cry for Me, Argentina"), was brought in to write lyrics for the rest of Menken's Aladdin score.

certainly the musical score was a major factor. When Academy Award time came around, *The Little Mermaid* was awarded two Oscars, and both were for its music. Lyricist Howard Ashman and composer Alan Menken won for Best Song for "Under the Sea," and Menken won for Best Score.

Two days after winning the Oscar, Ashman told Menken he had AIDS. It was now a race against time for the lyricist whose ability to embellish time with memorable lyrics was so great. They wrote a full version of *Aladdin* and showed it to Katzenberg. He liked some of what Ashman and Menken had done, but he preferred to have them go on to *Beauty and the Beast*.

It turned out to be the right priority. Ashman solved the *Beauty and the Beast* story problem that had baffled Walt Disney and caused him to put it aside after working on it for a while years before. The classic fairy tale concerns a maiden who is taken prisoner by a beast and transforms him by love.

"Howard said, 'The Beast is the guy with the problem,'" recalled Don Hahn, the producer of the film. "'He's got to redeem himself by movie's end. His act of love allows the girl to leave his castle.'"

Menken and Ashman had found the way to work on stories that had been popular with listeners for hundreds if not thousands of years. "The story existed in the verbal culture of storytelling long before it was ever written down," said Hahn. "Part of the fun is that each generation adapts this powerful story to its own time and culture. This is the twentieth-century Disney version."

It was in that spirit that Howard Ashman and Alan Menken created six new songs for *Beauty and the Beast*.

The best song was the ballad that won the Academy Award as the Best Song of 1991—the title song. It accompanied the state-of-the-art sequence in which the hand-animated lead characters express their love by dancing in a computer-animated ballroom that seems to move in waltz-time with the dancers—the way we feel rooms move when we're in love in them.

Aladdin needed to be a major departure for Disney's animated features in tone and style, and *Aladdin*'s new songs had to reflect that wilder tone and more exotic style.

"Howard wrote a treatment which was different from the story that has been animated now," said Menken, "and we wrote the songs to fit that treatment. Three of them remain—'Friend Like Me,' 'Arabian Nights,' and 'Prince Ali'—but you start from the story, you start from the characters, and where the plot goes. You know that you need to fit in an opening number, you need to have a number that expresses what the character wants, what his or her dreams are. You have certain production numbers that come later on for entertainment value. You have comedic numbers. There's a balance that just works—and so you basically take that from the story and you find your place for the songs."

But when Musker and Clements began *Aladdin*, they changed the approach—seeing it as more of an adventure-comedy with a strong romantic interest at its center. These are the elements they stressed in their screen story; these are the elements they wanted underscored in the songs.

After Ashman's death, Tim Rice wrote lyrics to Menken melodies for two more songs that fit a lighter, more fun-filled tone than that of *Beauty and the Beast*.

"Arabian Nights," lyrics by Howard Ashman, music by Alan Menken, is the scene-setter for the story. In a Broadway musical the scene-setter would conjure up in our imaginations sights the stage cannot show, as in this "land from a faraway place, where the caravan camels roam." This animated film musical not only can show a lengthy camel caravan, both in sandstorm and setting sun, but will produce the whole City of Agrabah, Sultan's Palace and all, magically appearing, as if summoned by the song.

"One Jump Ahead," lyrics by Tim Rice, music by Alan Menken, is the song that defines the personality of Aladdin—a rakish young man with a heart of gold who must nevertheless live by his wits. Animation allows him to sing his song not only "one jump ahead of the breadline," but graphically—up on the screen—"one swing ahead of the sword"—as Rasoul and the guards chase Aladdin and Abu through the marketplace and Aladdin sings—and swings—away.

"Friend Like Me," lyrics by Howard Ashman and music by Alan Menken, lets the Genie "illuminate the possibilities" of their friendship in a surreal comedic number ("Life is your restaurant and I'm your maitre d'"). This song provides as important a narrative function as "Arabian Nights" and "One Jump Ahead," because the friendship of Aladdin and the Genie is pivotal to this retelling of the story. As John Musker puts it: "Although Aladdin is poor and homeless, he's got good values beneath that 'marketplace thief' surface of his. His loyalty to his friend, the Genie—when not doing the right thing seems to be the better course for him—will show in the end that the Genie has a real friend in Aladdin, too. Aladdin delivers on his promise to free the Genie—and even if it means losing the girl that he's fallen in love with." This comic song foreshadows that serious climax.

"Prince Ali," one of the last songs written by Howard Ashman with Alan Menken, is the big production number that accompanies Aladdin's grand procession (posing as Prince Ali Ababwa) through the streets of Agrabah to the Palace.

The romantic ballad, "A Whole New World," lyrics by Tim Rice, music by Alan Menken, is a whole new approach to the love duet which has provided some of the greatest moments in the musical history of Broadway shows and Hollywood films. Back in *Show Boat* days, Gaylord Ravenal and Magnolia Hawks sang "Only

Below: scenes from all the songs in Aladdin (top to bottom): Aladdin's song, "One Jump Ahead," music by Alan Menken, lyrics by Tim Rice; "A Whole New World," the Menken/Rice love duet for Aladdin and the Princess Jasmine; and "Arabian Nights," music by Menken, lyrics by Howard Ashman, the song that sets the tone of the story. At bottom, left to right, two more Ashman/Menken songs: "Friend Like Me," sung by the Genie, and "Prince Ali," the rousing song that accompanies Aladdin to the Palace posing as Prince Ali Ababwa.

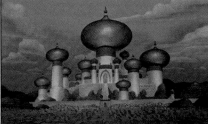

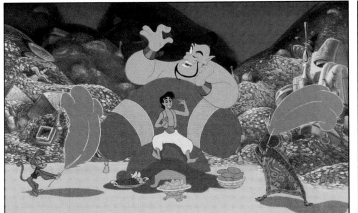

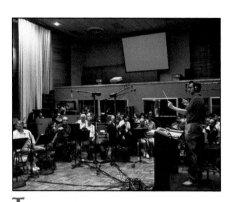

The orchestration of Menken's Aladdin score is recorded. His reorchestration and rerecording of the climax of Beauty and the Beast at the last possible moment was thought to be a factor in the Oscar won by that score.

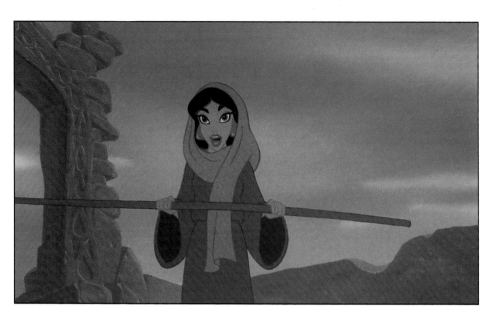

Early Jasmine designs by Mark Henn. Most Disney characters undergo a design evolution.

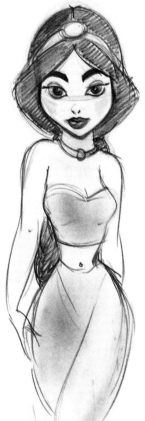

Make Believe" and "You Are Love" in down-to-earth (or down-to-riverbank) locations, as did Nelson Eddy and Jeanette MacDonald in every duet they sang, from "Ah, Sweet Mystery of Life" in *Naughty Marietta* to "Sweethearts." The locale for the love duet in *Aladdin*, however, is a flying carpet in flight around the world. As Jasmine (singing voice by Lea Salonga; speaking voice by Linda Larkin) and Aladdin (singing voice by Brad Kane; speaking voice by Scott Weinger) blend their voices on "A Whole New World," and Jasmine sings of the "unbelievable sights, indescribable feeling, soaring, tumbling, free-wheeling through an endless diamond sky..." the animated scenes in color blend with the music to describe that feeling audiovisually. "Hold your breath," says Aladdin, halfway through the song. "It gets better."

In aiming to be a Disney voice, however, it is advisable not to hold one's breath. The process can take months—or even years. Pre-schooler Peter Behn's voice actually changed between his first audition to be Thumper's voice in Bambi and his last recording session. Linda Larkin hoped to be told, at the end of her October 1990 first audition, that she would be the speaking voice of the Princess Jasmine. She would not have believed that nine months later, she would still be fighting for the role. Looking back, however, she is cheerily convinced that all the suspense, struggle, and frustration were worth it.

"For my first audition," Linda recalled, "I went into the studio on Flower Street in Glendale, and I saw two friends of mine there to audition for the same part. But it was so special to me that it was like a dream. I first read for Albert Tavares, the casting director. I read two scenes. And one of them was the Magic Carpet scene with Aladdin, where Jasmine says, 'It's all so magical.'

"When I finished reading, Albert looked at me and he just smiled and said, 'Linda, that was wonder-

ful.' I said thanks, and I left. I didn't know if he was really enamored of it, or if he was just trying to be nice. I didn't hear anything for a month."

In November 1990, Linda was called back for a second audition.

"It was kind of a long walk from the waiting room they had us in back to this screening room where we auditioned—kind of a maze," said Linda, "so Albert would walk each of us back."

Even from the "sides" she had studied, Linda Larkin knew that the Princess Jasmine was a self-confident young woman. So as Albert was walking her to the room where she was going to audition, she said to him:

"I want you to know that I'm going to do this."

He turned to her and laughed, and said, "Well, I'm glad you're confident, Linda."

"I have a really strong feeling about this," she replied. "It really is special to me. But if it's not this, it's going to be something else. I know that I'm going to do Disney animation."

She thought, "There are a lot of factors that go into casting something. I may not get this particular job for whatever reason, but I know that this is going to be part of my acting career."

At this second audition, Linda met Ron Clements and John Musker for the first time.

"John and Ron were dressed very casually, and I've never met more pleasant people. But you wouldn't believe to look at them that these men were brilliant and creative and amazing. Here they were, sitting in there in jeans and T-shirts and sneakers, deciding my life.

"I was in a studio," recalled Linda. "There was a piano there, and there were seats set up—it must have been a screening room. I'll bet a screen came down behind us, because there was a booth behind the seats that was probably a projection booth. I just barely exchanged 'hellos' with Ron and John and Don Ernst, then I did my stuff. They didn't even really direct me on it. Then I left.

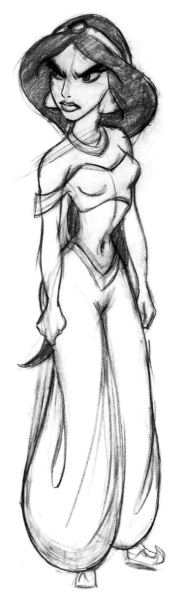

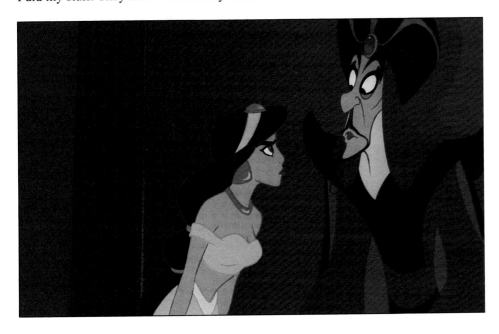

Jafar conveys his male chauvinist attitude by telling Jasmine that "a beautiful desert bloom such as yourself should be on the arm of the most powerful man in the world." But Jasmine 's attitude is just as clear. "I am not a prize to be won...If I do marry, I want it to be for love." The ground is prepared for conflict.

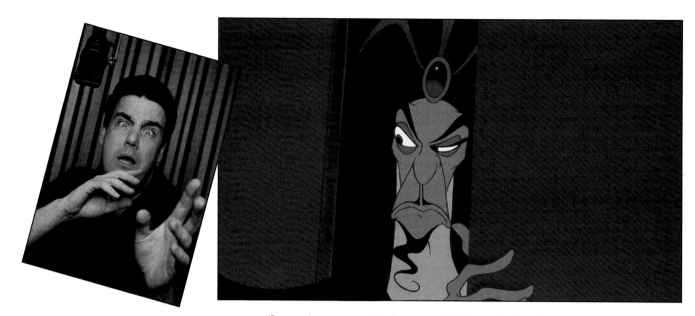

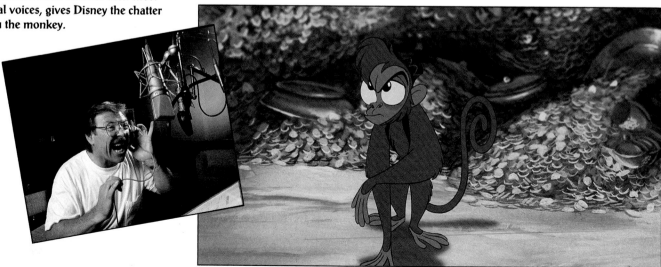

Above: Jonathan Freeman, the voice of Aladdin's villain and a connoisseur of Disney villainy, plays Jafar as a character "blinded by greed."

Below: Frank Welker, who has given George Lucas films some of their most unusual voices, gives Disney the chatter of Abu the monkey.

"I went home over Christmas of 1990, and when I came back, I had a third call, and I was, like, 'WOW! A third call-back!' But that's when they told me that Jeffrey was resistant. They wanted to do a four-hour session. That was in January 1991.

"This time, when I went in, John, Ron, and Don were all pushing for me. They worked with me. But it was still an audition. I mean, the first two auditions were regular auditions, like I go on every day—but that third audition, the big audition, the four-hour audition, I got paid to do.

"While I was recording, Ron or John said, 'This is one of the things that Jeffrey wants to hear.' And that was when I first got the hint that Jeffrey Katzenberg was still not sure about me.

"I still hadn't met Jeffrey Katzenberg," Linda Larkin said to me, at our lunch on the Burbank lot in April 1992. "But at that time, I was six months into the project. I had auditioned in October 1990 and had my first call-back in November 1990, and I believe Jeffrey had heard my first audition tapes—or maybe just the second one. And now I was auditioning for four more hours.

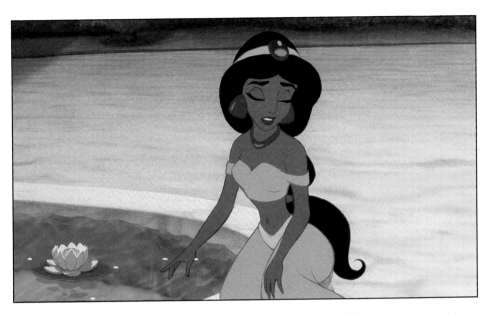

"One week after I did that four-hour session, they told me that they had convinced Jeffrey and the job was mine. They had gotten my voice to the point that he was looking for."

But Linda's face didn't reflect the joy of that occasion; her eyes were already conveying the reality of six months later.

"In July 1991, after I had been the voice of Jasmine for six months, they started auditioning more girls for the part," she said.

Linda was silent for a moment. Finally, she said, "You know, it was difficult for me.

"Ron, John and Don really went to bat for me," said Linda. "But there was a quality in my voice that Jeffrey apparently didn't feel was appropriate for this character. And it was the same thing he had objected to from the beginning. I had to lower my register."

In that lower register, she articulated her triumph.

"Well, we finally made it work. We got my voice to the point where Jeffrey was finally convinced that it was going to be all right."

One of the benefits of finally being Jasmine was that she got to act with the chap who signed a contract to do the voices of the Genie and the Peddler.

"We met at a sound studio over by the other Disney studios in Glendale. The Princess does not have a lot of interaction with the Genie in this movie, but Scott [Weinger] had gotten to record with the voice of the Genie, and I said, 'If Scott gets to record with the Genie, I want to record with him.' I went to the sound stage one day, when Scott and he were both recording, just went to watch. And I said, 'Can I go inside?' And they said, 'Sure.' They called over the microphone, 'Genie, Scott—the Princess is on her way in.' And I came in, and I met the Genie, and he and Scott happened to be doing a scene, right at that point, that the Princess was in. Don Ernst's assistant, Manda, was reading my lines. The booth

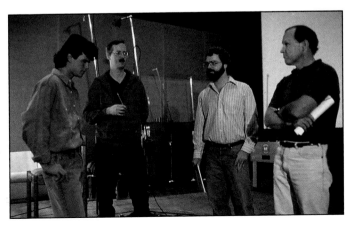

"*G*oodnight, my handsome prince." Jasmine finds love when she is returned to her balcony after a Magic Carpet ride around the world with Aladdin.

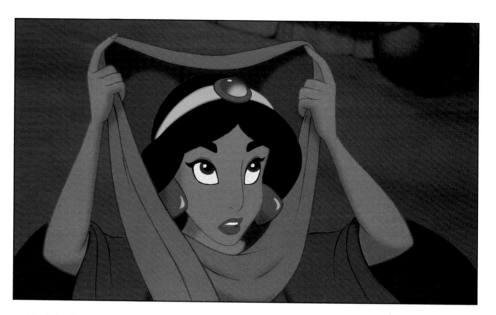

*B*elow: Doug Krohn of Mark Henn's Jasmine unit, animates the motivating action: the Princess who loves the poor boy throws wine in the rich Jafar's face for his effrontery in calling her "my Queen." Deja will follow up with animation of a burning-faced Jafar snarling, "I'll teach you some respect."

said, 'Linda, would you mind jumping up to the microphone?' And I said, 'Not at all, of course not.' And I got up to the microphone and I shared a microphone with Scott because they only had it set up for the two of them.

"That's how the three of us did a scene together. It was the scene where Aladdin is masquerading as the Prince, Ali Ababwa. She had already met Aladdin as himself, in the marketplace, so now the Genie turns himself into a bee to advise him.

"It was a wonderful experience for me as an actress, because the Genie improvises. Our lines are just written regular, but all his lines are written between brackets, such as, [SAY SOMETHING LIKE THIS…]. And he improvises, and goes on and on, and does such wonderful things.

"My lines would follow his, sometimes, and I'd have to watch him and feel out when he was about to stop. Then I had to come in."

In this sequence involving Linda as Jasmine, Scott Weinger as Aladdin, and the Genie, Aladdin, disguised as Prince Ali Ababwa, is alone with Jasmine on a bal-

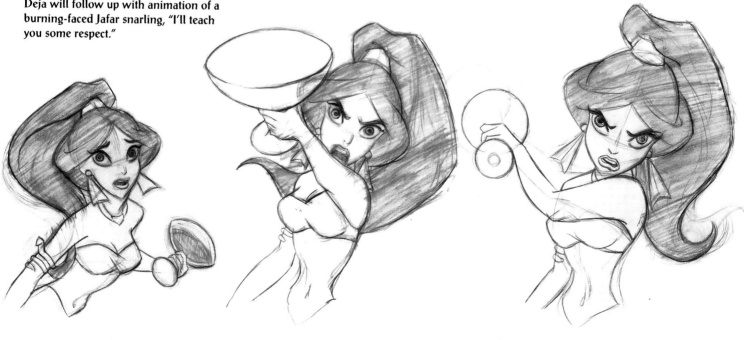

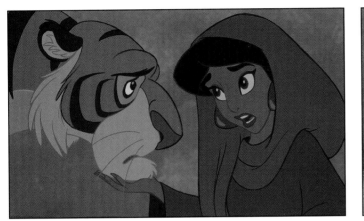

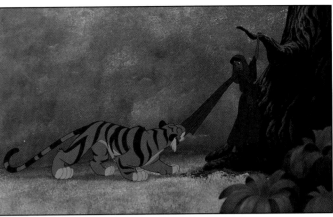

A bove: Jasmine in two scenes from the finished film. In traditional Disney style, she gives the key to her personality to an animal who is her friend. "I'm sorry, Rajah," she tells her pet tiger, "but I can't stay here and have my life lived for me."

cony at night. The pretend prince is bragging about all the servants he has, and seeing that his phoniness is turning off the Royal Princess, the Genie turns into a bee, buzzes close to Aladdin's ear, and reminds him:

"Remember: beeeeeee yourself!"

"So much of the stuff he did they can never use, because politically and socially it goes…beyond Disney," said Linda. "But it was a great thing for me, as an actress, to be able to listen to him."

When Mark Henn, meanwhile, heard the first audition tape of Linda Larkin's voice, he was convinced. He heard the same quality of sincerity that he had heard in the voice of his sister Beth.

"What works in Disney animation, particularly with voices, is that quality of sincerity," said Henn. "You always want to listen for that. Avoid sugar. Avoid cutesy pie. With Linda, there was something very different from the other voices we've had. This is the third heroine in a row for me—Ariel, Belle, and now Jasmine—and the thing I've always liked about Linda's voice was the quality of sincerity—but coupled with a quality that sounds different to me from Jodi and Paige. Her voice is a little lower, but also, there's a very individual spark and liveliness in her enthusiasm that made me think, 'Boy, if I could capture some of that in my animation, Jasmine would really be something.'" It was, in fact, the sound of determination—and it defines the personality of the princess Jasmine.

As Mark Henn "closed in on the end of the animation of Jasmine," he felt that he had captured it, and the character had come to life. "I'm just hanging on her coattails and holding on."

Funny that after drawing Jasmine thousands of times, he had never noticed that she wasn't wearing a coat.

Linda Larkin had done it. By being herself, and speaking in her own sincere, enthusiastic, determined voice, she had joined the caravan of Disney voices wending their way over the sands of time—a caravan that stretches back to Walt Disney himself as Mickey Mouse and includes among its hundreds of memorable voices a multicolored chorus of immortals.

And though she had never been married when she finished recording her role, Linda Larkin was already telling people that "my great-great-grandchildren will know me as the Princess Jasmine."

The Layout Department
Cries Havoc

Abu

In the imaginations of layout artists, camera angles and cuts from action to action appear as if on a screen, so that those perspectives and that staging can be brought to life in animation.

The workbook is the basic guide to both animators and background painters of how the staging and cutting of the scenes should look. These are three of 21 pages of workbook devoted to the Havoc Sequence drawn by Rasoul Azadani, head of layout on Aladdin. A field guide (opposite page, middle) defines the parameters of the monkey's movement in grabbing the jewel, as seen in the film frame at bottom right.

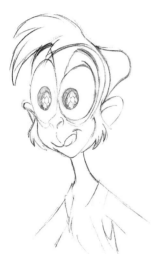

When the look of *Aladdin* existed only as inspirational drawings and paintings by the production designer and art director; as sketches pinned up on storyboards; as words in a screenplay, and in countless quick sketches of characters by animators in search of definite personalities, it was already the responsibility of Rasoul Azadani and his layout department to visualize the final appearance of the picture. Live-action directors and cinematographers choose camera angles for what stands before them; editors of live action cut film that already exists; but it is the glory of the layout artist to be able to draw pictures from the imagination, in sequence in a workbook, scene by scene.

Azadani worked with John Musker and Ron Clements as if he were a combination of the cinematographer and the editor of a live action feature before the fact, while at the same time working with Richard Vander Wende, Bill Perkins, and Kathy Altieri to make sure that their vision of *Aladdin*'s special style was not compromised by his way of visualizing the story as a design in motion.

Take this specific situation: When Aladdin and his monkey friend, Abu, enter the Cave of Wonders to look for the Magic Lamp, the Tiger-God allows them to proceed but clearly warns them:

"TOUCH NOTHING BUT THE LAMP."

Once down in the Cave, Abu races to a large treasure chest, and Aladdin has to warn him, "Abu! Don't touch anything. We gotta find that lamp."

That much is the story point, communicated visually and strongly by Ed Gombert's storyboard. The animation of Abu's supervising animator, Duncan

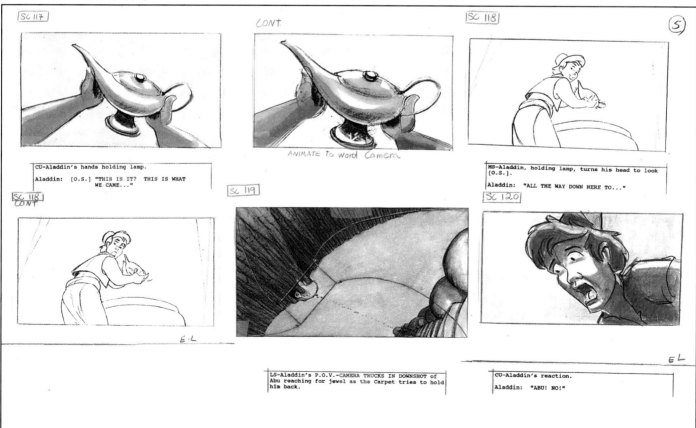

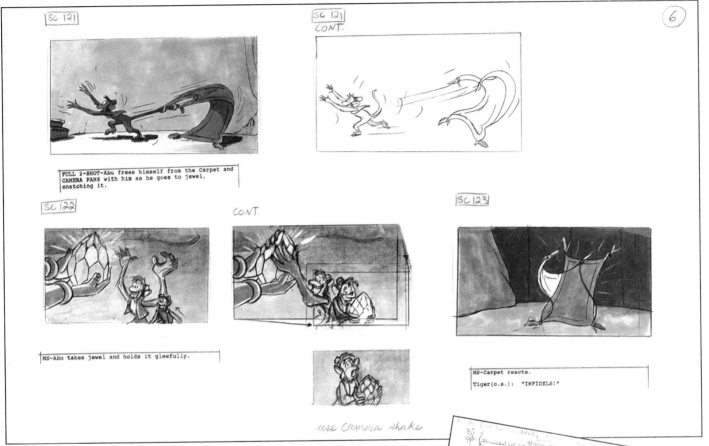

SC 121

SC 121
CONT.

FULL 2-SHOT-Abu frees himself from the Carpet and CAMERA PANS with him as he goes to jewel, snatching it.

SC 122

CONT.

SC 123

MS-Abu takes jewel and holds it gleefully.

MS-Carpet reacts.
Tiger(o.s.): "INFIDELS!"

use camera shake

Marjoribanks, will show us how inviting all this shiny treasure looks to the little monkey—and, sure enough, just about the time Aladdin spies a dented, dust-covered, dull metal lamp, Abu will spot a fantastically sparkly big red jewel held out by the hands of a giant monkey idol.

Abu pantomimes "for me?" and grabs that jewel. There will be a rumbling sound on the sound track. Don Paul's special effects unit will make dust fall from above. The ground will begin to quiver. We are fast approaching the climax of Sequence 10.5, the one that its sequence director, John Musker, calls "Havoc."

But first—this is a job for Azadani and "workbook"—front and shaking center! The artist who actually stages the action of an animated film is needed here.

The layout artist takes the storyboards and translates story sketches into the key scenes that indicate every change of camera angle, from CU (close up) to medium

When Abu touches the jewel, says the screenplay, "all hell breaks loose" in the Cave of Wonders.

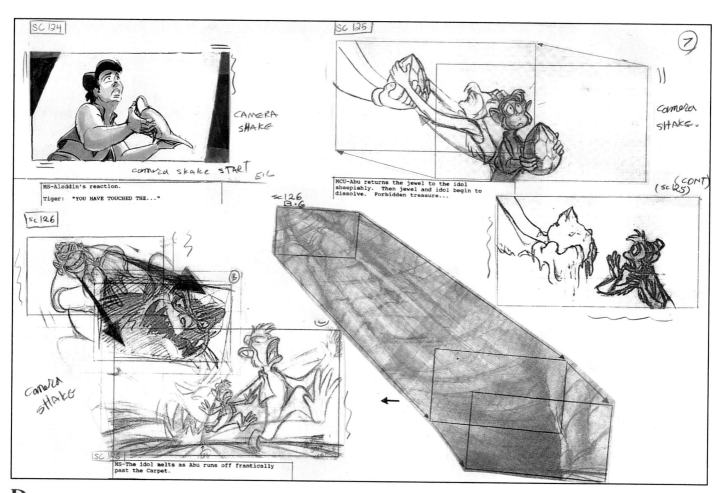

SC 124

CAMERA SHAKE

camera shake START SiC

MS-Aladdin's reaction.
Tiger: "YOU HAVE TOUCHED THE..."

SC 125

7

camera SHAKE.

MCU-Abu returns the jewel to the idol
sheepishly. Then jewel and idol begin to
dissolve. Forbidden treasure...

(CONT)
(sc 125)

SC 126

sc 126
B.G.

camera shake

SC 126

MS-The idol melts as Abu runs off frantically
past the Carpet.

Duncan Marjoribanks impressed Ron Clements with the range of feelings he gave Sebastian, the shellfish loyal to the Little Mermaid, so when Clements and Musker began planning Aladdin, they made him Supervising Animator on the jewel-fixated monkey, Abu.

shot to long shot to XLS (extra long shot)—and the important gradations in-between. Those layout drawings go into the workbook and workbook pages are xeroxed.

Now, in the screenplay, to explain the visual action worked out in detail on the storyboards, the best that words can do to capture what should happen on the screen is as follows:

"ALL HELL BREAKS LOOSE.

"The cavern SHAKES violently. The monolith stairway magically transforms into a chute—Aladdin clutches the lamp as he slides down the chute toward the pool—now transformed to boiling lava. Just in time, the Carpet zooms in, catches him. They streak to grab up Abu, who is about to be crushed beneath falling stone.

"INT. TREASURE CHAMBER

"The piles of treasure TRANSFORM into mountains of fire, the flames reaching for Aladdin and Abu, scorching the carpet as they fly through.

"EXT. CAVE OF WONDERS

"Outside, the earth TREMBLES. Winds swirl ferociously. Lightning FLASHES, thunder BOOMS. The Tiger's head ROARS as if in agony. Jafar watches, intently; Iago frightfully peers out from his cloak."

That's all there is in the screenplay to guide the animators in giving the viewer the most intense visual experience of the film.

The words require the reader to use his own unaided imagination to conjure up a Treasure Chamber, a Cave of Wonders—to imagine all the camera angles at breakneck speed that Azadani will devise after a career of thinking camera angles.

From the beginning of animated features, layout artists have worked side by side with directors, as Azadani is working beside Musker now, to keep track of what is happening in a film's space while the director is most concerned with what is happening in the film's time.

The problem, of course, lies in staying true, all at once, to the best pace for the viewer to move through space in the film; and the best "look" that space can have—the vision of the art director, which, on *Aladdin*, derives from Bill Perkins's interpretation of Richard Vander Wende's overall design.

The flavor of the drawings of this Middle Eastern environment for Aladdin were partly inspired by 1,800 color photographs taken by Rasoul Azadani of his hometown.

Just before the Gulf War of 1991, Azadani took a research trip to his native Iran. In his home town of Ispahan, from whence the fictitious adventurer Hajji Baba of Ispahan set out in the bestseller of 1824, Azadani took 1,800 pho-

Rasoul Azadani (above), draws the workbook page (left) that turns the script phrase "all hell breaks loose" into concrete images, including those picturing steps turning into a slide that a horrified Aladdin pitches off towards burning lava. Animators, background and effects artists turn these drawings into the scenes from the film at bottom.

Artistic coordinator Dan Hansen "workbooks" the Genie's first appearance.

tos of buildings and interiors to help other Disney artists picture the Islamic world of the fifteenth century with authenticity.

From Iran to California, the screen is constantly on Azadani's mind. He is as close to being a human camera as you get on an animated film. When he and Musker decide on the presentation of the scene, Azadani retires to his room and begins to draw. The actual background paintings will be based on his original sketches. So will the animator's drawings of what goes on in the environments of those backgrounds.

It is Azadani's job to tell whether the scene will be a longshot, a close-up, a pan, and on through the vocabulary of film. He decides whether the "camera" of his eye will be at normal eye level, high level, or low level.

At CalArts, Azadani studied layout with Ray Aragon, "a wonderful artist who laid out parts of *Sleeping Beauty* and *101 Dalmatians*." In this film, he gets a virtuoso's chance to show what he has learned. "In *Aladdin*, besides supervising all the layout artists, I'm working personally on some of the sequences. Let me show you some of the drawings of the 'Havoc' sequence. It's really exciting."

In his mind's eye, Azadani sees the monolith stairway magically transform itself into a chute. He envisions—and draws—a far shot of Aladdin running down the stairs. He draws a far shot of those steps turning into a slide and Aladdin sliding down.

Okay, now let's have a far shot of Aladdin sliding into the camera. Then a medium long shot of Aladdin pitching off the slide right toward the burning lava. Now, Azadani decrees a close-up of Aladdin's horrified reaction.

Musker will allot that close-up two feet of film—thirty-two frames—perhaps as many drawings. Musker and Glen Keane, supervising animator of Aladdin, will hand that scene out to Mike Cedeno of the Aladdin unit to draw it—and to make Aladdin's horror animated.

Aladdin's carpet (top), and lava patterns (above and right) are all done by hand animation and enhanced by artists M. J. Turner and James Tooley, working on computers.

The layout man plans everything that will come within the camera's scope: backgrounds, characters, props, clouds, landscape, etc. And he must keep all these things in proper scale at all times. So Azadani's layout sketches for the workbook envision not only the chute and the boiling lava (which computer-generated imagery and special effects must put on the boil), not only the Cave of Wonders and the Treasure Room, not only Aladdin himself, but also his fellow passenger down this treacherous chute, little Abu…and the Flying Carpet who saves Aladdin at the last minute.

Azadani calls for a shot from Aladdin's point of view in which the camera will truck in on the boiling lava just as a flash of Carpet appears. Now a far shot of the Carpet saving Aladdin. And then a far shot from Aladdin's point of view of him swooping away from the lava on the Carpet, then veering back in the other direction. But where is Abu?

Rasoul Azadani to the rescue: A long shot of Abu hopping across the rocks. Now make the camera eye seem to swivel over to reveal the stepping stones disappearing before him. A far shot of Aladdin steering the carpet toward Abu. Close-ups of rocks exploding. And soon it's time for the far shot of Aladdin on the Carpet whisking Abu up beside him, saving the little monkey from the plunging rock.

Actually, the Havoc is only beginning in the mind of the layout man working on the great reckoning in his little room as Aladdin says:

"CARPET, LET'S MOVE!"

But down the hall in the Hart Building, Duncan Marjoribanks is already worrying about how Abu is going to react to all this. Well, after all, he thinks, Abu caused it by grabbing the forbidden jewel.

"That's central to Abu's personality, his lust for jewels," Marjoribanks says. "Abu is basically Aladdin's best friend. He's a child-like, curious, sort of a street thief of a capuchin monkey without the depth of character of Aladdin. He's in this film for contrast to the changes that Aladdin goes through in spirit."

Marjoribanks's model sheet for Abu did not include comments written beside the drawings, as many other animators do. "Not too much," he says. "Mostly I just drew."

But he did write, beside one drawing: "Note difference between hands and feet. His feet are longer and he has prehensile toes. The thumb of his foot doesn't hinge in the same place as on his hand."

Azadani and his associates design the backgrounds, suggest patterns of action for the animators to follow, and indicate the camera positions that would result, hopefully, in the most imaginative staging and cuts that would tell the story.

"My job is basically staging the film," said Azadani. "I am separated from the work of Richard and Bill. I work with the directors, the animators, and the scene planners. I make sure the cuts, the continuity, and the main composition, stay the same from the workbook to the rough layouts."

In the Treasure Room of the Cave of Wonders, the Magic Carpet teases Abu by creeping up behind him and taking his hat.

The layout man gives to the animator 1) drawings showing the extent of the action; 2) drawings of the props; 3) rough sketches of the backgrounds. But Azadani's work isn't finished there. He must give the background artist a drawing showing the scope of the action. He may assist in filming live action as a guide for animation.

Azadani supervises the work of fourteen layout artists—twelve working in California; two working in Florida, in addition to laying out sequences himself.

The workbooks ended up in three big volumes, and each big workbook is seventeen inches long by eleven inches tall.

"When we do the work, we show it to John and Ron. They may say, 'Well, I'd like to have a little more upshot,' for example—to make the scene more dynamic. So we draw it more upshot. Then, when we do the rough layout, basically, we push it a little more there, toward upshot. Then, we show it to the director again before it goes to the animator.

"The animator animates it, and then, when the drawings come back to us again, to clean up their roughs, we push it again to refine it more. 'Pushing it' means pushing toward refining the animator's staging, his drawing. We can get more into the style of the film, better lighting on it, and be sure that the composition that the animator has made works with our layout."

"When Aladdin and Abu get through the Havoc, Jafar is happy because he thinks he has the lamp," says Azadani. "He's getting up and he realizes that the lamp is gone."

Trainers brought a monkey (above) and a parrot to the Disney Studio so that animators could combine realistic animal and bird anatomy with caricatured human traits for Abu and Iago.

Like real monkeys, "Abu's feet longer than hands with prehensile toes." Here, he is drawn by Duncan Marjoribanks.

We will learn in another sequence that Abu, the thieving little monkey, has stolen it from the wicked Wazir, but for now, our emotions are caught by the narrow escape of Aladdin and his sidekick capuchin from the terrible Havoc. And it was Rasoul Azadani and his layout artists who made that escape as exciting as a thrill ride at Walt Disney World—which it someday may be. And Abu can be thanked for causing it all—the little monkey.

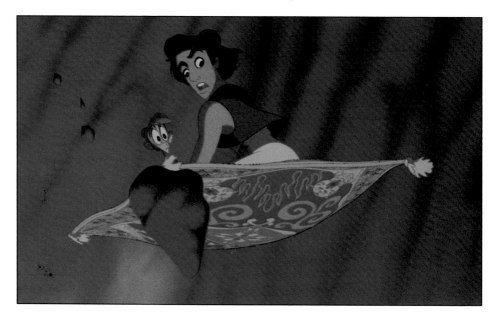

Oh, and one more thing: never in the world can writing "CAMERA SWIVELS OVER to reveal steppingstones disappearing before Abu as he hops across the rocks" even approximate what animation can show us happening on the screen—or make us feel what seeing Abu's awareness of his impending doom does.

Moreover, state-of-the-art special effects can make the transformation of a pool of cool blue water into a boiling reddish lava a virtuoso display of hybrid effects: by James Tooley of CGI (computer-generated imagery) with hand-drawn effects combined.

Don Paul, the special effects supervisor on Aladdin, takes the boiling lava a giant step beyond the boiling lava in the "Rite of Spring" segment of *Fantasia*. The horror of molten lava flowing after our hero and his animal and carpet pals inspired Paul to try for a new treatment of lava.

"We're trying really hard to combine computer and drawn effects together on this film in such a way that they blend enough so that you don't notice what's computer animated and what's hand drawn," said Paul.

"Look at this lava. That's actually painted texture of the surface of the lava, and then we scanned it in and did a computer move on it to get the surface we wanted. Then we'd go back in on it and we'd animate lava bubbles moving up and down and bursting.

"We work with a grid box so that when we do the surface, we get perspective on it. Then I'll work with an animator to make sure that the bubble is traveling up and down on the surface properly. Then we make sure that we light it the same way as we lit the paintings so that they will blend together."

In the making of *Aladdin*, storyboards were drawn to visualize what the action might be, but not to clarify the precise location of the characters in the story's locales. Building on those sketches, the layout artists' minds moved like cameras among imagined characters and through imagined backgrounds. They made it clear where the characters were and where they were headed, from Agrabah to the End of the World. They clothed the characters in authentic costumes and moved them among authentic architecture and landscapes. Their cuts created a tempo for the action that helped create the mood of the picture: slow pans and trucks in the quieter sequences; short scenes and fast cuts making for exciting sequences like the Havoc. They menaced Aladdin with lava—and CGI and special effects made it happen. And in the end, the layouts had inspired everyone from the animators to the composer with the greater possibilities in a visual presentation as imaginative as the exotic old story of *Aladdin* itself.

"Why, you hairy little thief!" says Aladdin, as Abu hands him the lamp that Jafar was willing to kill for.

The Living Line
Aladdin

Supervising Animator Glen Keane is animating Aladdin's eyebrows. Keane's pencil cavorts on the paper and the pencil marks become lines that become bold dark brows. As Keane flips the drawings, the brows tilt rakishly. Aladdin is misrepresenting himself to the beautiful Princess Jasmine as Prince Ali Ababwa.

Keane, who looks like Huck Finn grown up, tilts the light brown brows of his own open, freckled face, as if he were Aladdin being rakish, then lays down the pencil in his freckle-backed right hand, and looks up for confirmation at the pictures on his wall.

Still photographs of Tom Cruise in *Top Gun*, his own dark and rakish eyebrows atilt, smile conspiratorially down.

"Tom Cruise is a big influence," says Keane. "There's an intensity to Tom Cruise that I want for Aladdin. I wanted to steer away from the Wimp Prince. What Ariel in *The Little Mermaid* did for the spunky Disney heroine is what we want Aladdin to do for the male leads. There's an intensity to Cruise's face," says Keane. "Did you see *Far and Away*? It's those heavy dark eyebrows, the way the nose comes straight down from the forehead—and he's got this boyish sort of a smile, but he's slightly dangerous, too."

Keane is mainly concerned with what animators call "inner struggles." Fast action is the forte of some animators; others specialize in their characters' thought processes. And what Aladdin thinks about a lot, Keane has found, is his inner struggle with false pride.

Aladdin knows that his ostentatious display as Prince Ali Ababwa is only courtesy of the Genie, of course. But when the Genie warns him, "Al, all joking aside, you really ought to be yourself," Aladdin replies, "Hey, that's the last thing I want to be." Instead of feeling justifiable self-respect at the cool bravery he displayed when he saved Jasmine's life in the marketplace, Aladdin denies being himself.

Glen Keane (standing), supervising animator on the character of Aladdin, reviews his animation with Ron Clements, who directed Sequence 13, "Aladdin Becomes Prince."

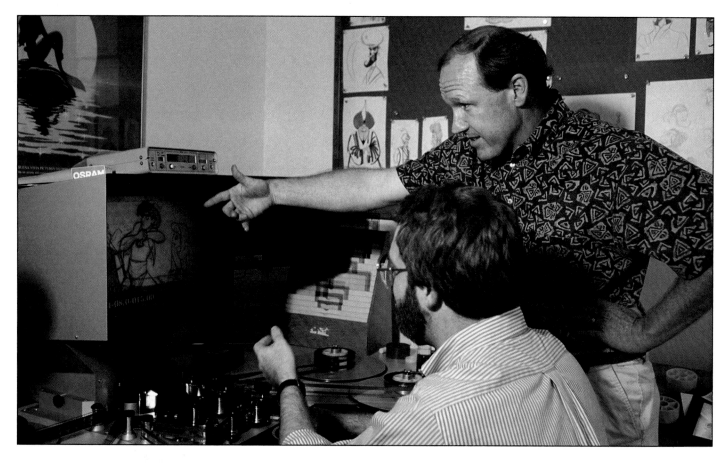

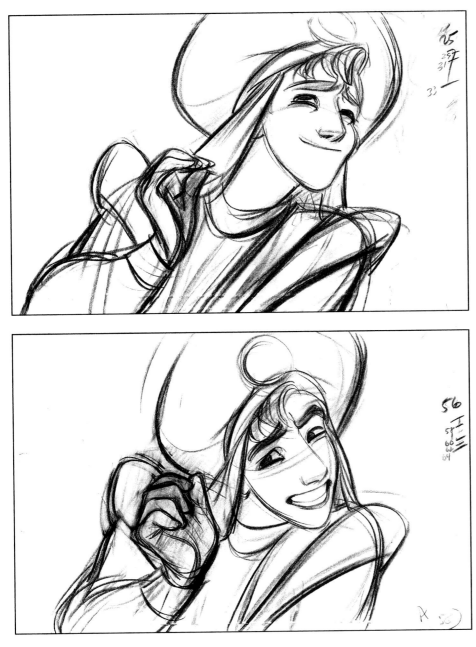

Glen Keane's philosophy of animation is spelled out in his notes to the crew of artists who will clean up these five rough animation drawings as the production deadline nears so, says Keane, "We can emphasize quality in the crunch time when quantity is the word. Feel the action: Roll [flip] several drawings"—as when, above, Aladdin tries to praise Jasmine by calling her "punctual."

"The truth is," Aladdin lies, "I, ah, I sometimes dress as a commoner, um, to escape the pressures of palace life. Yeah!"

Under Keane's leadership as supervising animator of the character of the hero, the fifteen animators in his unit are making a movie which could also be a graphic textbook on the comic and dramatic use of eyebrows, valuable for any actor who benefits from careful observation—for animators, as has often been observed, are basically actors with pencils. Their oral encyclopedia of eyebrow usage is partially created out of their study of Tom Cruise movies; partially remembered out of lifetimes of brow-watching; but above all, guided by the live-action reference footage shot of Rob Willoughby and Robina Ritchie, the live-action models for the characters of Aladdin and Jasmine.

Aladdin walks boldly forth in thumbnail sketches by Keane and Tony DeRosa. These thumbnails, which continue on the next page, are studies for Aladdin's song, "One Jump Ahead."

On Wednesday, April 29, 1992, Keane sat in silent absorption at the Debbie Reynolds Dance Studio. He was watching a dancer choreograph the movements of Aladdin running from the guards in the market place, for the first song in the film. It is a bouncy tune by Alan Menken with lyrics by Tim Rice, called "One Jump Ahead." Their movements were being photographed as live-action reference material for Keane and other animators, but what was wanted was not a literal transcription of those movements, but the illusion of light, rapid movement such as few human beings possess.

"What I was telling the animators in my unit who will work on this song," said Keane, "is that we should just have one big sign that we put up in front of the desk of everyone who is animating the character, and it would just say ATTITUDE. Because Aladdin has to have an attitude—and that attitude has to be in every move

Keane's animation philosophy results in expressive finished frames of Aladdin being himself and posing as Prince Ali and (below, left and right): "Emphasize the changes: What is the pose coming out of—going into?"

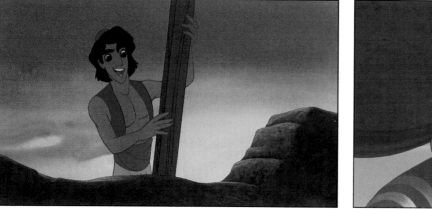 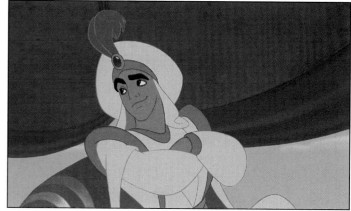

he makes. He can't just be running away from the guards—he's got to be taunting them, he's teasing them, he's 'in their face,' he's playing with them—and he's never afraid.

"Even if something horrible is about to happen, Aladdin never has a look of 100 percent terror. On the edge of surprise, the edge of fright, he's always thinking, 'How am I gonna handle this?' Aladdin's attitude is, 'Here's something else I'm going to tackle—and conquer.' Fearful situations are to him a challenge.

Keane's philosophy explains the sequence of thumbnails for "One Jump Ahead:" "Think in terms of movement: not one drawing at a time."

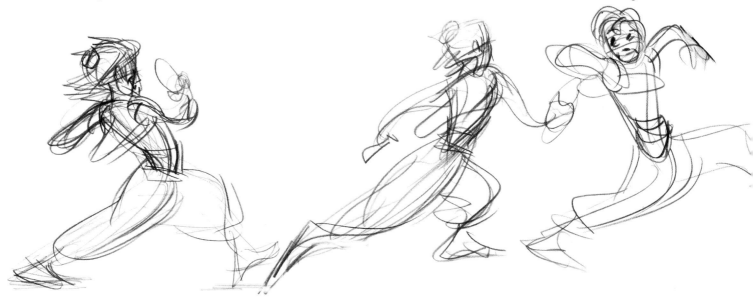

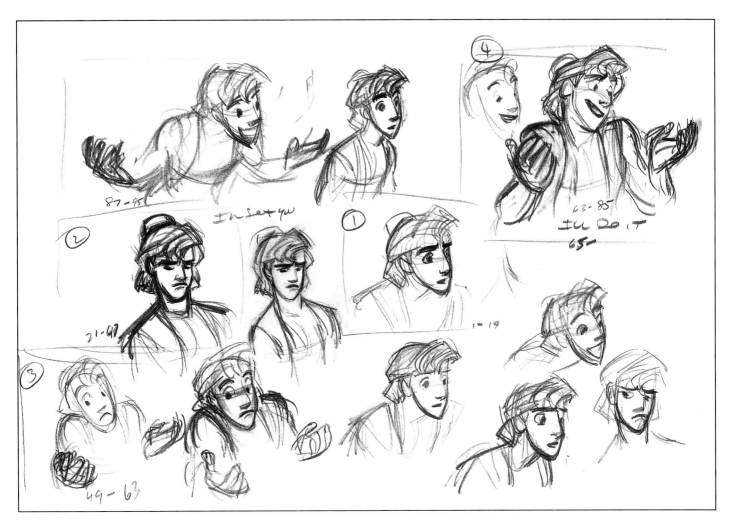

"We haven't really heard much from Aladdin in the way of dialogue at this point. And now we're hearing him sing. But after this song, you will know this character well, because every pose is going to have his attitude in it. Then you'll know what kind of a guy this is—which sets it up great for the whole film that he believes he's got this great destiny—that he's going to someday attain something, someday be at the palace, that he's going to get out of this street life—if he could just have a chance.

"'I could do it!' he says—and then he gets the chance. He gets the Genie, he gets the wishes—and that's the whole theme of the story—that if it's not on the inside of you, it's not real.

"This whole story is about people putting on costumes, putting on disguises, trying to be something they're not, and that's

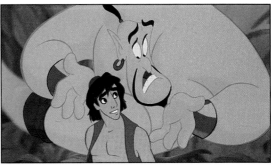

"Make it fluid: rhythmic and simple," says Keane— as in the play of eyebrows in the scene where Aladdin asks the Genie what his wish is and the Genie says he wants to be free. Aladdin unthinkingly says "I'll do it"— only later realizing the consequences if a man's word is to be his bond.

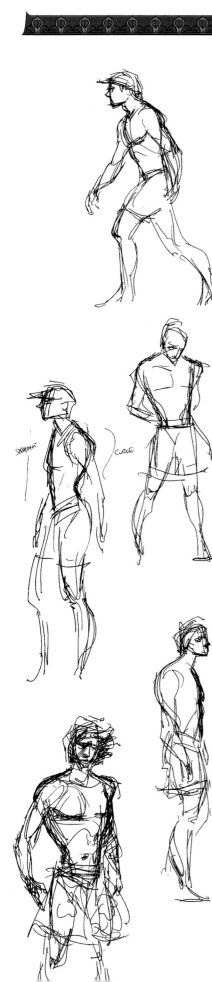

not real. Aladdin does it, Jasmine does it, Jafar does it. Abu the monkey is an elephant instead of a monkey through much of the movie. Everybody is running around in disguises through this whole film, even the Genie. You can never tell what character he's going to pop into next."

Keane is a great teacher, because he's a great animator who can not only animate, but can explain what he does. And one of the most important things that he does constantly is contrast and compare.

"I always have my sketchbook with me, and wherever I go, I draw. I may not remember people's names, I may not remember what they wore—but I remember something about a person that my wife, Linda, will never remember. Linda will remember what a lady wore, what her shoes were, what color eyes she had—but I'll remember what her body attitude was, the tilt of her head—I'll remember her air of security, or confidence, or insecurity, or fear, or nervousness. Those things I notice.

"I watch people in the mall when Linda's shopping, or at airports while we're waiting. There are times when I can sit in the backseat of a car and sketch.

"I think I've really learned from Hirschfeld. He said that he'd draw little sketches and then write words next to those drawings—you know, like 'chicken fricassee' for somebody's flabby arm, or 'spaghetti' next to the hair. Then, months later, he can do a drawing based on that little sketch and the words that bring him back to the impression that this image gave him at the time."

Just so, when Glen Keane was assigned to find out who Aladdin is and to animate him. Keane says he compared him first to a fifteenth-century Michael J. Fox, and then a fifteenth-century Tom Cruise.

"To me, Tom Cruise is one of the elements in our Aladdin, and Michael J. Fox is another. Originally, we were really patterning him after a Michael J. Fox character. He's the kind of guy that things don't go right for initially, but somehow it turns out okay in the end.

"But I think that the problem that Jeffrey was starting to have with a Michael J. Fox Aladdin is that Jasmine was so beautiful and so dignified, Jeffrey couldn't see what she saw in

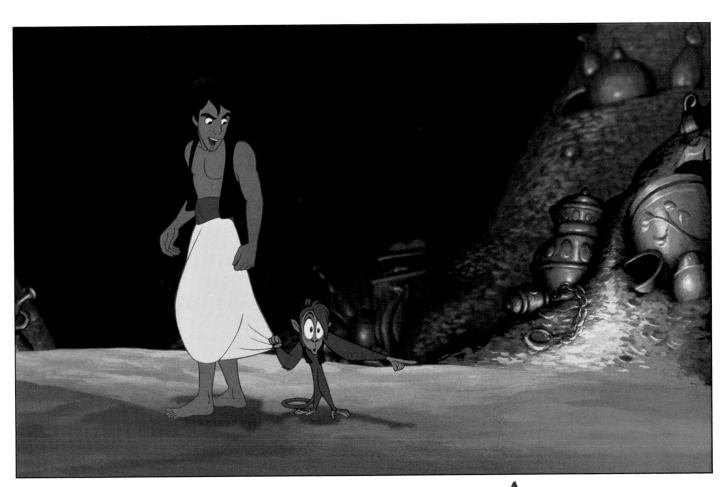

Aladdin when we were playing him a little more boyish, a little more klutzy. So Jeffrey said, 'Look at Tom Cruise. Look at *Top Gun*, and see what it is in him, and get that in Aladdin.'"

So Keane and the Aladdin crew watched *Top Gun* on video, over and over.

"We noted that in all of his poses, there was a confidence and a strength. And they were all athletic poses. There was a confidence in the way he stood—the way he flew his jet fighter—the way he did anything."

But above all, Aladdin, like Tom Cruise, had to have what Keane calls "likability."

"When a Tom Cruise character is acting like a jerk, everyone in the audience is looking at him, and they're feeling, 'Ah, come on! Don't be that way!' That's an important thing for any character—or any person. A good test of whether you like somebody or not is to see them start to head off in a direction they shouldn't be going in, and if you're rooting for them not to, that means you love them, somehow. Something has clicked between you and that person."

With an animated cartoon character, said Keane, "You would be amazed at how easily audiences can stop rooting for a character. All it takes is somebody drawing a pose where Aladdin is kind of sitting back and just watching—and it's gone."

Keane has spent eighteen years learning to move drawings that express the emotions he believes his characters would feel, but he has spent nearly his whole life learning to draw. Drawing itself is something he related to as far back as he can

Aladdin, seen in full figure as in the model sheet, explores the Treasure Room of the Cave of Wonders with his best friend, Abu. When Aladdin has Abu on his shoulder or otherwise acting in a scene with him, animators from Glen Keane's Aladdin unit must harmonize their intentions with Duncan Marjoribank's Abu unit.

Opposite page: Glen Keane remembers where Aladdin started for him: "After Beauty and the Beast, our family rented a house on Manhattan Beach and I started doing design work on Aladdin based on some young volleyball players. I took special note of the triangular torso shape, width of shoulders, narrowness of waist—they became the basis for the Aladdin design."

A color model of Aladdin shows his definite silhouette.

remember. Indeed, in Br'er Rabbit's terminology, Glen Keane the cartoonist was "born and bred in the brier patch." His father, Bil Keane, created and still draws the syndicated comic panel, "The Family Circus," and is a winner of the Reuben, the Oscar of Cartooning, awarded annually by the National Cartoonists' Society. In the spring of 1992, Glen received the award, presented by his father

Keane grew up in Paradise Valley, Arizona, where his father exposed him from early childhood to the best examples of art of all kinds. Young Glen turned out to have a great drawing talent, and went to develop it at CalArts, the college founded in Valencia, California, with money bequeathed by Walt Disney.

At CalArts, not surprisingly, Keane discovered animation. He was inspired to combine his obvious talent for drawing with his feeling that he could act.

Finding that he could act effectively through his drawings, Keane went directly from CalArts to the Disney Studio in 1974. Eric Larson, one of Walt's "Nine Old Men," who had been charged with recruiting and beginning the training of the new generation of animators, prepared Keane so well that, on Glen's first animated feature, *The Rescuers* (1977), his supervising animator was Ollie Johnston—from Thumper to Baloo the Bear, one of animation's greatest actors. Keane assisted

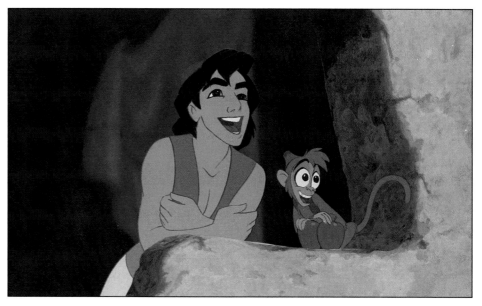

Johnston in animating the little orphan girl, Penny, as Johnston had long before assisted Freddy Moore in animating the dwarf Dopey.

Keane learned fast and moved up fast. After animating on *Pete's Dragon*, a combination of animation and live action starring Mickey Rooney, he became a supervising animator himself on *The Fox and the Hound*. Keane's animation of the climactic fight in which the fox saves the hound from a grizzly bear was widely regarded as the most memorable animation anyone in the new generation at Disney had yet produced. When New York City's Whitney Museum of American Art held its milestone retrospective "Disney Animation and Animators" in 1981, the sequence was shown continuously on a small screen in one of the galleries.

In *Mickey's Christmas Carol*, Keane animated Willie the Giant, a character originally created for Billy Gilbert (the voice of Sneezy in *Snow White and the Seven*

Aladdin dreams of the future with Abu, his monkey friend: "Someday Abu, all this is going to change, we'll be dressed in robes instead of rags. And we'll be inside instead of outside looking in. That'd be the life, huh, Abu? To be rich... live in a palace...and never have any problems at all."

Below: Keane's sketch for an early model sheet "before we decided on an older Aladdin."

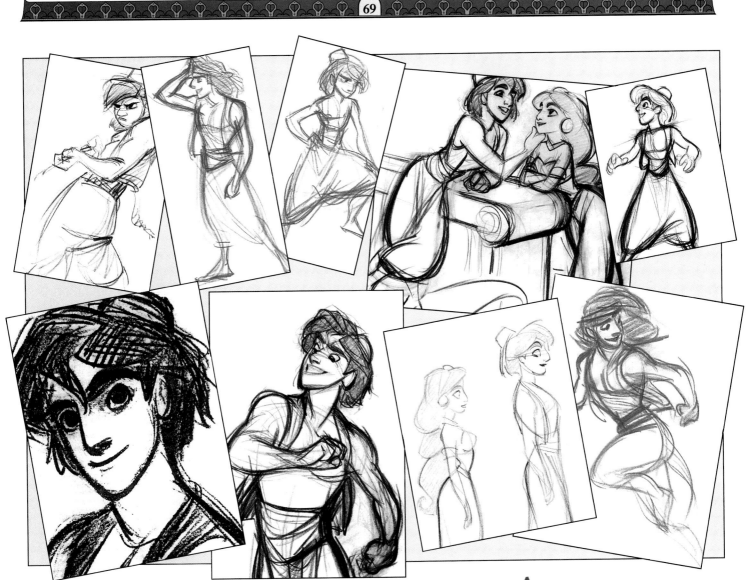

Dwarfs), in *Mickey and the Beanstalk* (1947). Keane's animation compared favorably with the original.

Keane designed all the characters in *The Great Mouse Detective* except Basil of Baker Street, and animated the vain and evil Ratigan. In 1983, he animated an experimental film based on Maurice Sendak's *Where the Wild Things Are*, which combined hand-drawn animation with computer-generated backgrounds and camera movements for the first time. Then he left the studio. "I worked at home, just freelance, but I was no longer an employee of Disney," he said.

Keane's freelance credits during this time included numerous remunerative animated television commercials, but his heart was in a fifteen-book series of Christian allegories which he continues to write and illustrate.

He came back to Disney to do *The Little Mermaid*. Because audiences had found his innovative character designs for *The Great Mouse Detective* appealing, he was asked to make Ariel look different from earlier Disney heroines, and to oversee the animation of the song that defines her, "Part of Your World." Keane conceived her movements under the inspiration—and the photograph on the wall of his room—of his wife, Linda.

Above: "A variety of Aladdin designs. We would pin these up on a board with a number next to each one in our design meetings," said Keane, "and try to narrow down the variations to 2 or 3 drawings that seemed to work the best. Then all of us would meet again the following week to do it again."

After the film was released, Keane knew that the magic was back when he talked with a swimming instructor who complained to him, "We've really had a problem teaching swimming to little girls since they saw *The Little Mermaid*. Now they don't like to use their arms to swim. They just kick their back feet as if they're fins because that's the way Ariel does it."

Imitation is the sincerest form of appreciating any performance.

Now, in the spring of 1992, Keane was struggling with Aladdin's feelings of inauthenticity, which Keane was convinced are much the same for both males and females.

"Finally, Aladdin has to learn that in order really to enjoy all of these things that he's getting, he's got to be real to himself. He's got to attain these things him-

Model Sheets are made for every character. The experimental drawings everyone likes best are mounted together on pages called Model Sheets—which becomes the design standard that must be followed by everyone working on the film.

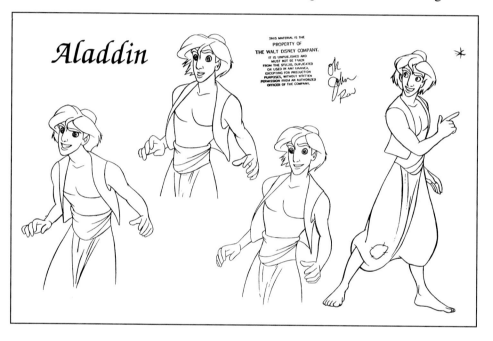

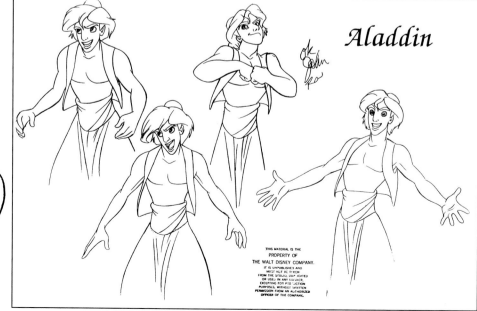

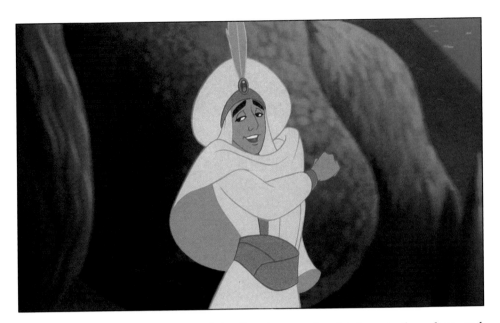

Aladdin in disguise as—in the words of the Genie, "Prince Ali! Prince Ali! Amorous he! Ali Ababwa! Heard your princess was a sight lovely to see..." and so parades to the Sultan's Palace to ask for her hand in marriage.

self—which he does. At the end of the film, he gets the girl, he gets the palace, and he gets the glory—but it isn't because somebody just handed them to him. He's living his own life."

Glen was also struggling to make Aladdin as real to the other animators in his unit—and in all the same ways—as he was to him.

"Animation is such a team effort no one man can take credit for a character. In the *Aladdin* unit, I have a great team of animators working with me doing vital acting moments in the film. The challenge is for all of us to think as one. The lead animator sets the pace for the character in the film. That's why each of the animators

Glen Keane's rough animation drawings depict Aladdin awkwardly wooing Princess Jasmine.

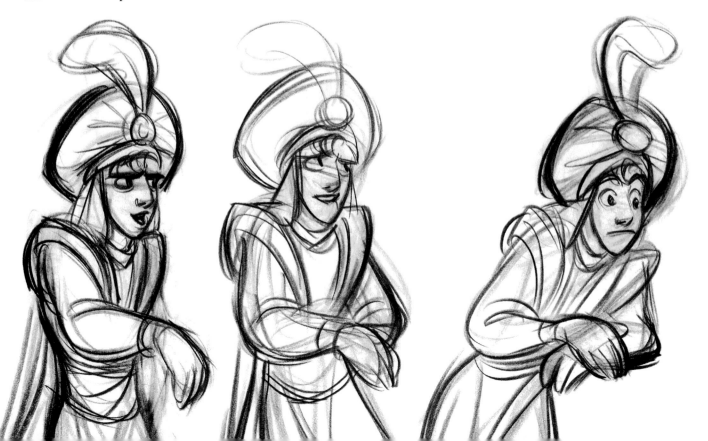

in my unit checks with me. Besides Ron and John, the lead animator is the only one who sees everybody's work and knows if somebody's heading off in this direction or that direction.

"He becomes the conscience of that character throughout the film. If one of Aladdin's personality traits are violated, I have to speak up in Aladdin's behalf in the film, and raise my hand and say, 'Hey, that's not me, that's not me—I wouldn't do that.'"

Like all the supervising animators, Keane works with the directors in casting the animators according to their strengths and weaknesses.

"A lot of times, the scenes that are the most difficult to do are the ones where there's the least amount of action, where the internal struggles are going on, and where the animator has to animate from the heart. The people who animate from the heart can usually do the broad as well as the subtle. They can usually do anything.

"The danger for any animator is the trap of your animation becoming an intellectual exercise of just moving drawings across the screen. You become a puppeteer, moving marionettes with strings. The effect for the audience is that somebody's controlling the character on the screen.

Kent Melton, a sculptor, makes maquettes—small models a few inches tall of all the characters to help animators visualize them in three dimensions. At right, the entire cast of Aladdin is assembled on a table top. The maquettes made for Fantasia became coveted collector's items. Stokowski, Stravinsky, Balanchine and other artists posed with them.

Opposite page: A layout drawing shows the vertical pan down as Aladdin's body, sinking downward, "comes big into camera." Underneath, in four animation drawings, Aladdin unit animator Mike Cedeno draws as if he were a camera trucking back as Aladdin sinks. At far right, for the balcony scene, three frames of live action show Rob Willoughby, the model for Aladdin, throwing his arms wide in a gesture of elation that is exaggerated below in the animation by Mike Cedeno.

"But with the guy who animates from the heart, it's him up there. It's not a puppet; it's him. He's up on the screen, and he's alive, and it sparks. But I feel that the best way to set the pace is to animate. You know, to do some scenes."

Working out the timing on a character has been one of the toughest challenges for a Disney animator from the beginning. "If you can time the way they move in one scene, every other scene can relate to that, even if the movements are much different," said Keane. "For example, how does Aladdin run around a corner? What is the timing when he turns his head? What is the attitude of his shoulders? Is his chest pushed out far enough? If you get the right flavor to that scene, you can have that for comparison in all the other scenes."

Abraham Lincoln had a motto which could be the supervising animator's credo: "If we could first know where we are, and whither we are tending, we could

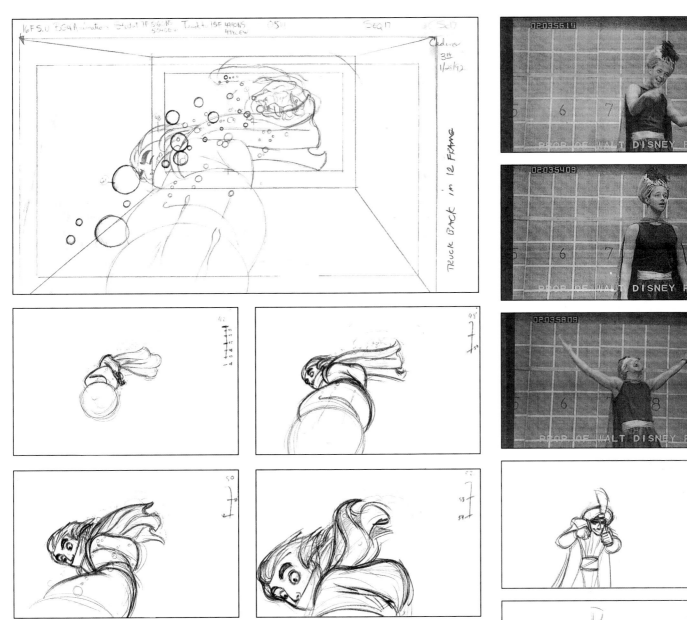

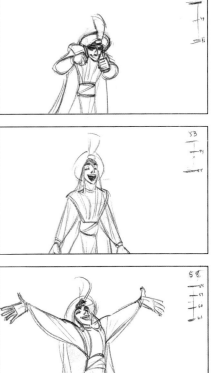

better know what to do, and how to go about it." Glen Keane thinks of this as keeping an eye on all the links in a chain—making sure no one is dangerously weak.

"Here's an example," he says. "When Aladdin sees Jafar for the first time, he's dressed as Prince Ali. One of the animators was animating the scene where Jafar comes up to Aladdin and says, 'Where did you say you were from?' Aladdin's line is, 'Well, much further than you've been, I'm sure.' Well, this animator interpreted Aladdin's line as showing that he's a little nervous that he's going to be found out. And he has Aladdin looking as if he's thinking, 'Yikes!'

"I saw his scene and felt it was undermining the buildup of Aladdin, because all through the section he's setting himself up for the fall that happens when Jasmine comes out and hears him say, 'Just let her meet me. I'll win your daughter.' You know, he's setting himself up for the fall, and the audience has to see it that way. But if you interpret him as being nervous and

The Aladdin Unit: Left to right: Top: Tony Fucile, Randy Haycock, Ken Hettig, Mark Kennedy, Brad Kuha, T. Dan Hofstedt, Phil Young. 2nd: Pres Romanillos, Russ Edmonds, Randy Cartwright, Mike Cedeno, Tim Allen, Tony Derosa. Bottom: Mike Swoftord, Mike Surrey, Glen Keane, Dave Stephan, Bill Recinos.

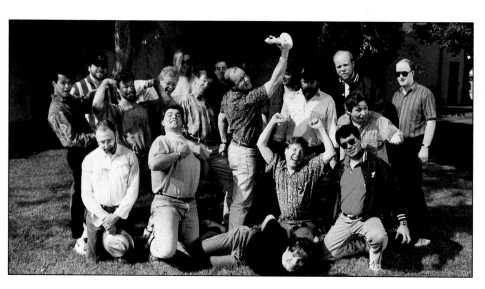

As deadline approaches on Aladdin, animators express their tensions (naturally) in drawings.

thinking he's vulnerable, then you let the air out of the tire; it's not going to roll any longer.

"John Musker and the animator agreed, and the scene was redone—which by this late stage in production almost required signed permission from the Pope. Animation had to be completed in ten weeks from then—July 5—and we still had just about half the film to animate.

"Now, I understand that you get caught up in a scene—you think, 'I'm really sure this is going to work'—and it was working great, it was animated beautifully, but it just kind of took a link out of the chain in the middle.

"So I realized more than ever before how we have to follow the progression of a character through a film so that we can see the changes happening to him.

"I've been telling the story of this scene to all of the animators in my unit," said Keane, "because I want them to understand how every scene is a link in a chain. We have fifteen animators all animating *Aladdin*, and each of those strengthen the chain if we are all aware of the stages in our character's development."

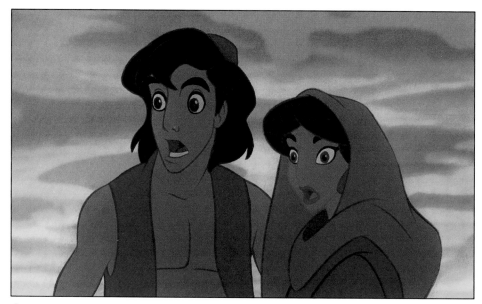

What everyone can count on is that the highly developed empathy of an animator means that he will see the story from the point of view of the character that he has been assigned to animate, no matter who or what it is.

Animator Will Finn said it with tongue only half in cheek: "*The Little Mermaid* was about a valet with a white wig and pipe—my character, Grimsby. *Beauty and the Beast* was the story of a frustrated clock trying to hold the fort in an enchanted castle. And *Aladdin* is the story of a devious parrot and a few of his friends."

The conflicting points of view of the different personalities often give the drama to the scenes. "Aladdin's viewpoint is, if he wants it, he goes and gets it," says Glen Keane. "He sees things very simply on the street, so Aladdin asks the Genie, 'What would you wish for?' And the Genie tells him, 'Oh, I wish for freedom.' And Aladdin's thinking, 'Oh, freedom—that's wonderful!' And the Genie says, 'Oh, but that will never happen.' 'Why not?' asks Aladdin. The Genie says, 'Wake up and smell the hummus. The only way I get out of this is if my master wishes me out. So you can guess how often that's happened.' And Aladdin, in the scene that I was working on, says, 'I'll do it!' That's Sequence 13, scene 21.50. I animated this scene four different times because it was seemingly an obvious scene where Aladdin says, 'I'll do it. I'll set you free.' But I didn't believe it.

"I animated it the first time where he comes up like he's struggling over it as if he understands the weight of this decision. And then he says, 'I'll do it.'

"But it just didn't play right.

"So until I got to the point where Aladdin looks like 'What's the big deal? I'll do it—I'll set you free,' I didn't have it.

"Then I realized that Aladdin doesn't understand the implications here. There is a reason why nobody ever sets the Genie free on the third wish. There's a difficulty to that which Aladdin has no comprehension of until it comes time, later on in the picture, to free him—and he realizes how important that last wish is.

"You've got to set that up. Every scene is a setup for something that's going to happen later on down the line. So if you had Aladdin, at this early point in the story say, 'Oh, this is a tough decision'…"

Keane pantomimes the way it would look if Aladdin treated the decision as a tough one.

"See, you've ruined it," he said. "The interpretation you want is—"

Glen Keane made his voice sound "no-big-deal"-ish.

"Oh, I'll do it," he said. "I'll set you free."

And then he sat down at his drawing board and animated it just that way.

Typical of the communications, verbal and written, that pass constantly among artists on a Disney feature is Glen Keane's "Note to staff about Aladdin's hair design change" based on the haircut of Aladdin's live-action model, Rob Willoughby, in the filming of reference footage Keane had just seen.

In the final weeks of animation, Keane drew up a "sheet of reminders for animators to keep in mind while animating Aladdin."

The Color of Villainy

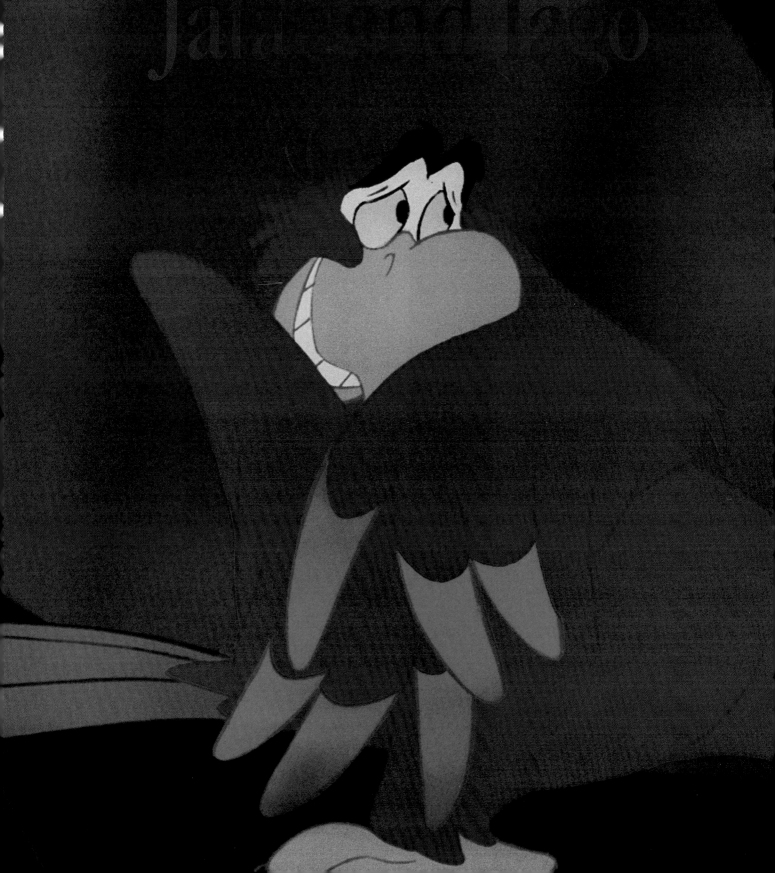

I have been snooping around the Disney Studios for so many years, gathering material for articles and books on animation, that when the Disney animators needed a villain for *The Rescuers*, directing animator Milt Kahl caricatured me.

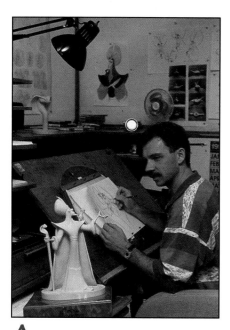

Andreas Deja at his drawing board.

In fact, Woolie Reitherman, the director of the whole feature, called my character "Mr. Snoops."

So I have had occasion to think a lot about Disney villains as I contemplate my newest fellow-villains, Jafar, the sallow, red-and-black-robed wicked Wazir of *Aladdin*, and Iago, the red, blue, and yellow parrot who sits plotting on the Wazir's

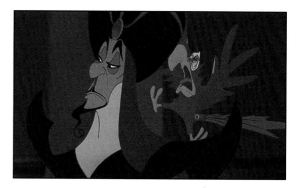

outrageously flared padded shoulder. I have come to the conclusion that a major reason that the Disney features have been so very successful in their villains, from Snow White's purple-adorned jealous Queen and the black-wearing witch she becomes, to Jafar's seemingly controlled but soon-to-explode sycophant of power-lust and greed, is their true colors. Even before their wicked words reach you with the speed of sound, their evil appearances have hit you at the speed of light with the shape and colors of villainy.

It happens again, very early in *Aladdin*. When the off-screen narrator tells you that the story "begins on a dark night where a dark man waits with a dark purpose," you see a dark and menacing silhouette that starlight will soon reveal as a big, red riding hood—in the big, bad underworld sense of the word.

Dark and red in *Aladdin* have been associated with evil throughout the film, and this is our introduction to Jafar's design and color scheme. As the screenplay puts it, "Motionless, he looks as though he has been waiting on those silent dunes for a thousand years. His name is Jafar. His mind works the way he looks: all long lines and deep sharp angles."

The strongly silhouetted shape of Jafar, the Wicked Wazir.

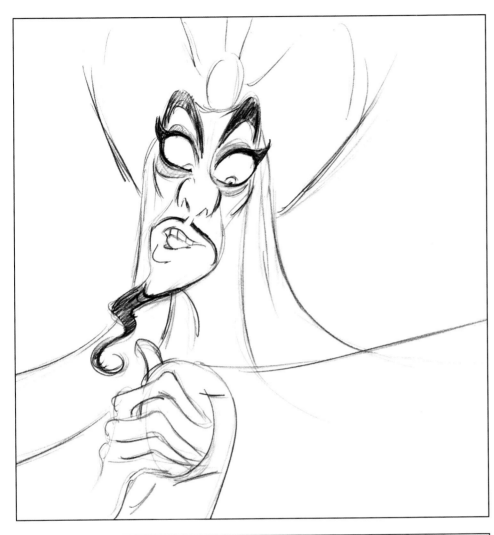

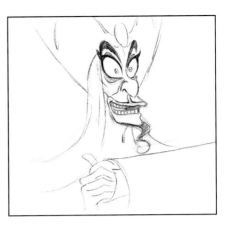

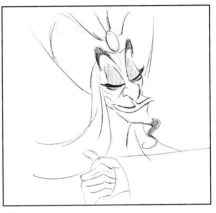

The design and animation of Jafar by Andreas Deja give him lips contorted by egotism and greed and eyes full of power-lust. (Left and above).

Deja's rough animation of Jafar on a horse (left) results in the scene on the opposite page.

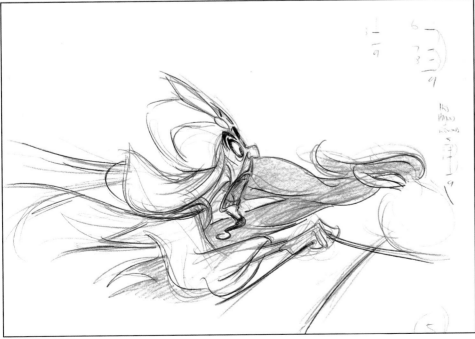

The long lines and sharp angles were given Jafar by his designer and supervising animator, Andreas Deja—the same designer and supervising animator of Gaston, the villain in *Beauty and the Beast*, of whom Janet Maslin, the *New York Times* film critic, wrote, "Gaston is theatrical and satiric in a way that adults will best understand."

But adults and children both will thoroughly understand, when they see that sharp, spiky form in robes of bloody red, that Jafar is meant to be bad, bad, bad.

Deja and Tim Burton, who became the director of *Batman* and *Batman Returns*, began at Disney together, designing characters for *The Black Cauldron*. Burton's designs were not used, and he soon left Disney and went into live-action film-making. Deja persevered through the debacle of *The Black Cauldron*, and was

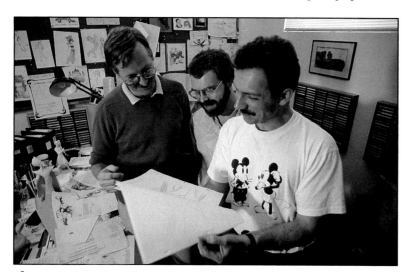

Andreas Deja (right) flips his Jafar animation for John Musker (left) and Ron Clements. As a child in Germany, Deja's heroes were Marc Davis and the late Milt Kahl, the most unerring draftsmen among Walt Disney's legendary Nine Old Men of animation. Deja grew up to be their colleague and peer.

put to work by Musker and Clements animating the Victoria-like Mouse Queen in *The Great Mouse Detective*. An artist who has been compared to Milt Kahl both as a draftsman and as an animator, Deja proved his enormous versatility in London, animating Roger Rabbit and assorted other characters in *Who Framed Roger Rabbit*. Then came another assignment from Musker and Clements: Triton, the mighty King of the Undersea, in *The Little Mermaid*. He reminded everybody of his versatility again when he animated Mickey Mouse in *The Prince and the Pauper*, and in the last two films, Deja has been cast as the animator of the villain.

Deja animated Disney's first male chauvinist character—the conceited, overbearing Gaston—with macho manners and arrogant, "Dating Game" good looks. Ashman and Menken gave him a song, "Gaston," that they called a "barroom waltz" with a brawling quality, sung in "tribute" to Gaston's very boorish qualities.

And Deja and Mark Henn, in animating Gaston and Belle, went for more three-dimensional characters in animation—personalities whose actions are capable of surprising viewers.

"When you first see Gaston, you don't think he's the villain," said Deja. "You figure he's going to be the Beast's rival for Belle's affections, but not malignantly. But as the plot develops and Belle rejects Gaston, you see him get so outraged that he becomes capable of killing."

On Jafar, too, Deja was aiming for the revelatory moment when the Wazir, blocked by Aladdin once too often, would go berserk.

"In the beginning," said Will Finn, Iago's supervising animator, "Jafar was the volatile, temper-tantrum character. He was always in a rage, very short fuse. More like Hook, more like Cruella and Medusa—very volatile and explosive. Always screaming. At that time, the parrot was always calming Jafar down, being very smooth, very Gielgud-like.

"And then Jeffrey Katzenberg saw what had been done, and he said, 'You'll get more menace out of Jafar if he's cool.' So that changed my parrot, because what are you going to do for contrast with two cool characters? So we made the parrot the one who's always losing his temper, and we get the comedy out of him.

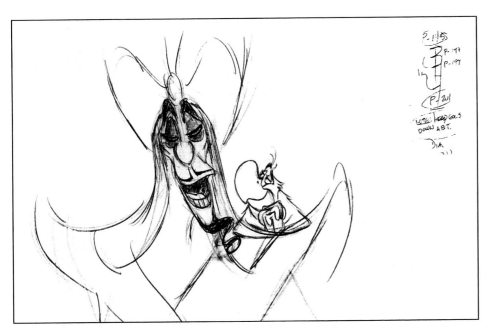

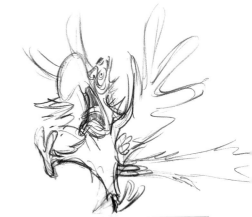

Jafar, animated by Andreas Deja, shares the same scene (though not the same high opinion each character has of himself) with Iago, here animated by Tony Bancroft. Below: Iago supervisor Will Finn finds an outrageous walk for the bird that matches both the personality and the design.

"Jafar instantly became a more sinister and threatening villain, and Iago immediately became a funnier parrot. And John and Ron were the ones who pitched Gilbert Gottfried for the voice. And the day they said to me, 'You're going to do the parrot and it's going to be Gilbert Gottfried,' I went home and said to Cindy, my wife: 'It's the days like this that make it all worthwhile.'"

For his part, Deja was delighted to reanalyze the character as an underplayed villain. He had decided to be an animator in the first place because, in Germany as a ten-year-old, he had seen *The Jungle Book*, and been "blown away" by Milt Kahl's underplaying of Shere Khan, the tiger.

"You try to make drawings that tell you who this guy is, how he speaks, what his mannerisms are. You listen to the recordings of the actor reading the character's lines, and you try to make someone else's words your own, his thoughts your own. Key to the character: greed, which turns ambition into power-lust. What does it feel like—real power-lust? From my observation, there are two kinds of power. There is creative power and there's power over people. When you talk about positive ambition, think of Walt Disney, trying to do the best he can, and taking other people along with him on the same quest. But when you think of someone using his power over people to cause harm, you're talking about dictators like Joseph Stalin—and you're getting Jafar.

"You look at television news—and you also look at people in your immediate environment who have this slimy, oily way of dealing with people, trying to get power over them.

"What drives Jafar?" he asked himself. "Hunger for power drives him," he answered. "It starts with ambition—and greed. Familiarize yourself with the story," he told himself, "and with people driven by greed and the lust for power."

Will Finn (above), Iago's Supervising Animator, kibbitzing with the live parrot who modeled for the bird side of this caricature of the contemptuous "assistant."

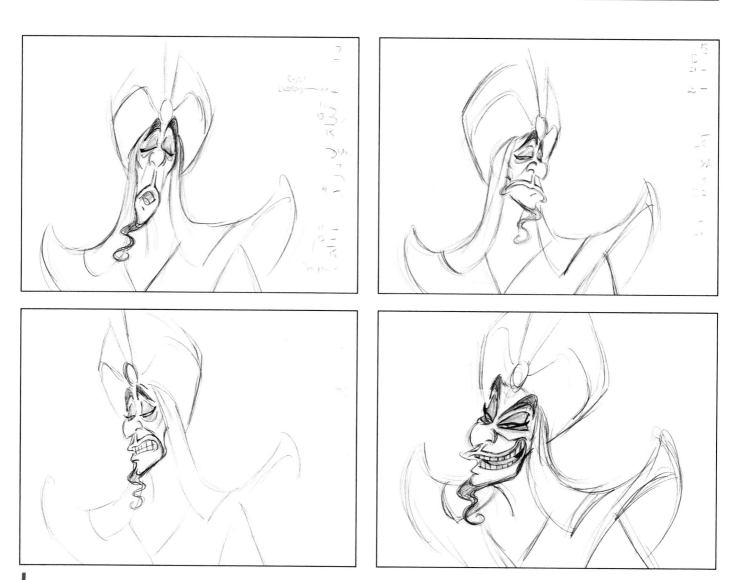

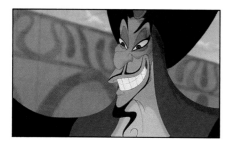

Jafar to Jasmine: "The boy was a criminal." Deja animated his dissection of a fake smile the same way Daumier drew his—by studying the phonies in the world around him.

As he drew, Deja analyzed and re-analyzed the character.

"From day one, Jafar has his eye on the Sultan's throne. Trying to find ways to get there in a situation where the Princess has to find a suitor quickly, he decides to marry her himself. His power-lust suggests to him that he could then murder the Sultan and ascend the throne very quickly. Once he gets the lamp, and he has three wishes, power corrupts him absolutely. I compare this with greed for money: 'You have $10,000, you want $50,000, you want a million, why not a hundred million?—why not a billion?—and so on.'

"Now I was getting insights into the character. Jafar wouldn't start out using violence. Being oily, he will start out trying to get what he wants through smooth talk, then through lies. Probably all of us have told a lie at some time. We all know what that feels like. Analyze what a liar looks like when he's lying.

"The production people want you to get that model sheet set, so that all the animators in your unit can get to work. But you can't settle too soon. You say 'Please leave me alone for a little bit yet.' You scribble a lot. You don't even try to make pretty final drawings. You do a lot of doodles—that turn into a lot of mouths—and suddenly something is evolving from the scribbles.

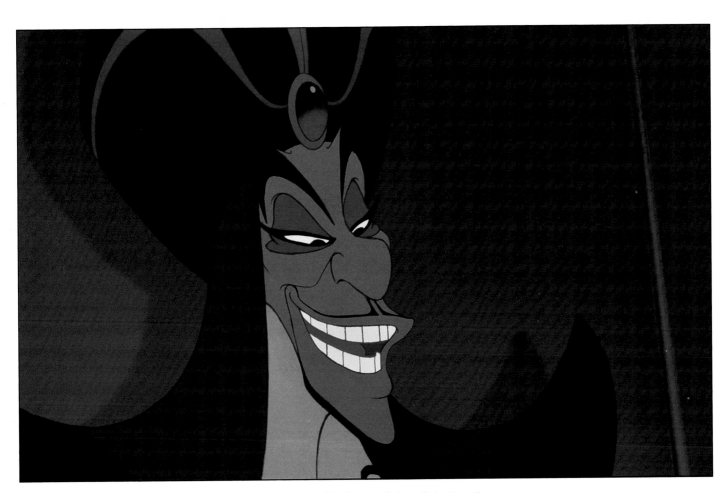

"I know the film will have a lot of close-ups of Jafar, so right off the bat, I want a face that looks like a mask for his greed and ambition. I want something that is stylized and yet has all the flexibility that I need for articulating dialogue and moods. And suddenly, a scrawl becomes these eyes that are tilted up toward the ends, and big eyebrows that are leading your eye down through the nose onto the mouth—and ending up in this little twirl of a chin, a corkscrew of hair that works as an accent in your drawings of his face. A scribble becomes a mustache and beard that organizes his facial hair to make a statement. He is masking his real emotions.

Jonathan Freeman, the voice of Jafar, marveled at the evolution of the character's look: "There were about 50 different pictures of a Jafar [see five below] out of which Andreas finally made his definitive model."

"Now we're getting the character. Duplicity is at the heart of Jafar. Aladdin must learn to be himself all the time—his true self is his best self; duplicitous Jafar is never himself.

"When I get the duplicitous face, Jafar is ready to play a most revealing scene. It's a sequence where Jasmine is confronting Jafar and complaining about

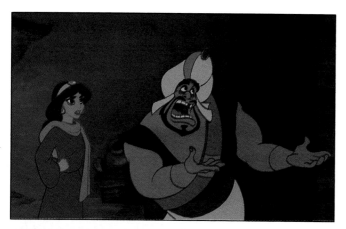

Aladdin's arrest. Of course, Jafar is the one who ordered Aladdin beheaded—yet he's acting so kind and solicitous of the young woman. 'Well,' he tells her in that oily voice, 'your father gave me the authority to keep the peace in Agrabah.' And then he adds, 'The boy was a criminal.' And he smiles.

"It's that smile that tells you who he is. You know when a person isn't smiling inside but forces himself to put on a smile: he clenches his teeth, the edges of the mouth go up and up, and his cheeks move up, too, causing the lower lids to disappear almost. I simply exaggerated all these reactions. When I showed the animation to John Musker, he wasn't expecting a very broad forced smile on the line, 'The boy was a criminal.' I said to him, 'I feel very strongly about this, John. Can't we live with it a while?' So John cut it in to the work reel, and when we had a screening for the animators—who are the toughest audience of all, well, it got a big laugh because it was so unexpected. John loves it now!"

Looking at the attitudes in his poses, I saw Jafar start to come to life and feel powerful emotions. Greed! Blind Ambition! Power-lust! Find them; hold them with lines of graphite on paper; make them work in key poses strong enough to convey those deadly sins when projected at 24 frames a second.

"The way that we came up with the concept of our villain, Jafar, was this," said Andreas Deja. "While I was still animating Gaston, the bad guy in *Beauty and the Beast*, some of our story people had started on *Aladdin*, and had started to draw some of the characters. So by the time I came on to *Aladdin*, a little work had been done on this guy.

"I took a look one day and saw one sketch that was kind of interesting. It gave me a very good idea of the type of actor we wanted—a guy who is into high fashion. Overpowering. He had a certain attitude that I could see in the sketch— except that I didn't really like the style. It was still very realistic, with a lot of detail,

Above: Phil Young, Supervising Animator on the characters of Aladdin's pursuers, Rasoul and the Guards. Below: color studies for the Sultan's palace under Jafar's rule.

and would be very complicated to animate. He also wouldn't be quite in line with what Eric Goldberg was doing with the Genie."

"I looked at another sketch," said Andreas. "Again, some of the personality came through—there was a certain arrogance I liked. But again, the drawing seemed very chiseled, and not that streamlined. So I got some other artists to caricature the character some more."

Deja looked at these drawings for good things he hadn't thought of: "I thought this one fell into the design of the movie," he said of someone else's draw-

Richard Vander Wende indicates a color contrast he seeks to Kathy Altieri and Bill Perkins.

ing. "This one here—again, the costume has stripes and some folds that were a little too complicated—including one of the strangest turbans I have ever seen. So I tossed that one.

"This one was done by John Musker. I love the attitude in his Jafar face, the long eyelids—really arrogant. Also, what's happening here with the shoulders I liked—the way they are pushed out."

Deja now produced some of his own early drawings of Jafar.

"These sketches were some of my early characters—and, again, I took a lot of the stuff that had already been done, and I tried to come up with something that was easy to animate, easy to turn, and would be very expressive."

"Easy to animate, easy to turn… expressive" are the Big Three on an Animator's Wish List when confronted with a character design; and Andreas Deja, as a top animator as well as a top character designer, knows this well.

Vander Wende worked out a color script for the whole film, sequence by sequence (left); above is the color script for the Genie's song, "Friend Like Me," by Howard Ashman and Alan Menken.

red paint= lite gem
staff pupil

red ink= staff pupil ink

ink- gem-hil-ink

gold

jafar/staff 12-5

flip for iago/sultan pal

ple paint= gem
staff iris

staff pupil hilite and ink

rple ink= feather ink
gem ink

staff e

black= paint
pupil
brow
moustache
hat
dress
cuff

black= ink
pupil
iris
eye
lower brow line
moustache

ins. cape

The color of villainy is different by night than in the day—as is demonstrated in the color model and scene from the film for day (top left and top right)—and the scenes from night (bottom, left and right).

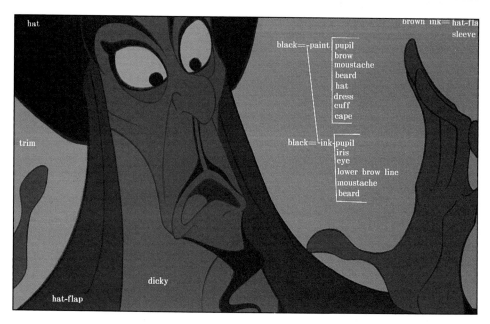

hat

brown ink= hat-fla
sleeve

black= paint
pupil
brow
moustache
beard
hat
dress
cuff
cape

black= ink
pupil
iris
eye
lower brow line
moustache
beard

trim

dicky

hat-flap

"I looked at some of Hirschfeld's drawings as well," said Andreas. "I also looked at Erté's drawings.

"This is basically what we came up with," he said, producing a colored drawing of Jafar. "You can see that the shapes are very reduced and very simplified, really. Very, very boiled down. Jafar's just a square with a skinny body in the middle, really. The focus is on his oversized turban, his dark, evil eyebrows, his long neck. The whole thing is meant to be streamlined. So he can turn properly."

Jafar may turn, for an animator's ease, like a box with a skinny body in the middle, but thanks to the colorists, even Maleficent in all her evil glory was not arrayed like this villain—from turban to toe to cobra-headed staff. And Iago, the parrot, is a rainbow of backtalk in red, blue and yellow.

"Iago is the first character I designed from scratch," said Will Finn. If Glen Keane's animation has the sincerity of Huckleberry Finn, Will Finn's animation has the imagination of Tom Sawyer Meets the Marx Brothers. His animation of Francis, the English bulldog in *Oliver & Company,* led to his animation on Grimsby the valet and Sebastian the crustacean in *The Little Mermaid*; Frank, the manic lizard in *The Rescuers Down Under*; and then to his triumph, Cogsworth, the clock with the voice of David Ogden Stiers of *M*A*S*H*, whose personality was "wound up tight," in *Beauty and the Beast.*

In *Aladdin*, for the first time, all the colors used in a Disney animated feature have been unified into a single color scheme by the appointment of one production designer, Richard Vander Wende. Bill Perkins and Kathy Altieri have both described themselves as committed to getting Vander Wende's unified "Aladdin 'style'" onto the screen as he conceived it.

"The *Aladdin* 'style' is the cumulative effect of numerous design decisions that have been made to support and strengthen the story," said Vander Wende. "The contrast between Aladdin and Jafar is the primary foundation for the visual structure."

Vander Wende and Perkins developed the style of *Aladdin* from the study of Persian miniature paintings from approximately 1000 to 1500 A.D.; various Victorian paintings of Eastern cultures, numerous photo-essay and coffee-table books on the Middle East; Disney animated films from the mid-Forties to the mid-Fifties, and Alexander Korda's 1940 film, *The Thief of Baghdad.*

Colored images of Jasmine and Jafar are combined with a colored background of the Palace.

From Gustav Tenggren to Richard Vander Wende, many stylists have influenced the whole appearance of the Disney features—planning, creating, inspiring and suggesting designs, colors, moods, locales, characters, and whole new fantasy worlds. But none of them until Vander Wende carried the title "production designer."

Vander Wende asked for a strengthening of what he calls "character/environment relationships":

"If we can extend (in the layouts, effects, and backgrounds) the visual characteristics of the main characters, we will strengthen the relationships—the similarities and differences—between them."

And so he developed his "visual character contrasts" between Aladdin and Jafar.

Vander Wende extended his own notion of color contrasts into a "general color contrasts" scheme in which evil was darker in value than good, more intense in saturation, and hotter in temperature; evil moving always toward red (Jafar) while good moves always toward blue-yellow.

He assigned general meanings to *Aladdin*'s palette:

Blue would stand for good, idealistic, romantic, cerebral, creative—and for sky and water.

Red would stand for "evil, hellish, fire, destructive/consumptive."

Green would be the natural color of "the good place," "the earthly paradise."

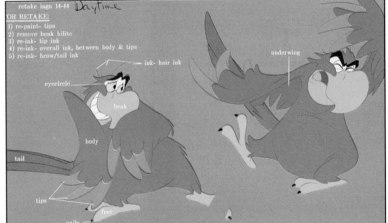

Iago in his daytime colors (above) gets his daytime red-blue-yellow in Disney's Color Model Department, headed up by Karen Comella.

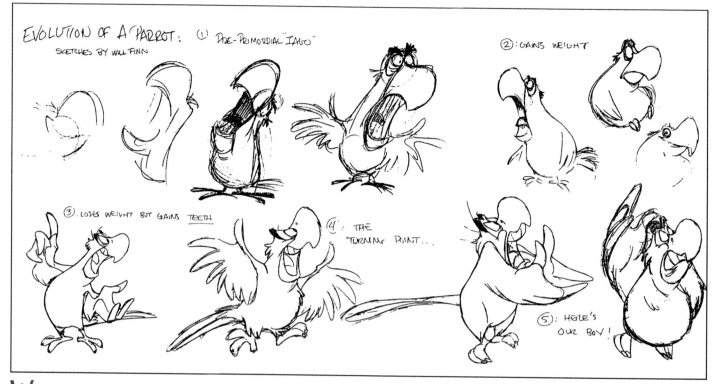

EVOLUTION OF A PARROT: ① PRE-PRIMORDIAL IAGO
SKETCHES BY WILL FINN

② : GAINS WEIGHT

③ . LOSES WEIGHT BUT GAINS TEETH

④ : THE TURNING POINT...

⑤ : HERE'S OUR BOY!

Will Finn's Evolution of a Parrot (above) didn't include enough flight instruction (below).

Yellow is an ambiguous color in *Aladdin*. An intense yellow symbolizes a mild evil, the evil that money is the root of. It is the color of gold and the material wealth of both the treasure cave and the palace. A more neutral yellow, however, is "down-to-earth," and, therefore, good—the color of natural elements, of sand and city.

And so, he designed a great mandala, evenly divided between Evil and Good. Jafar and Jasmine are its opposite poles. The Genie has a foot in both hemispheres. The city, the Sultan and his Palace, and Abu are all in the good half, but nearest to the evil half. The Flying Carpet is in the Genie's good quadrant. Aladdin is moving toward the polestar of Jasmine's goodness.

This is the approach of Vander Wende, Perkins and Altieri. Their imaginations change hues to express emotional developments, accompany the picture's structural flow with changing color values, shift color saturations from neutral to intense as moods shift from humorous to murderous, and raise the color temperature from Aladdin's cool "Are you afraid to fight me yourself, you cowardly snake?" to the last of Jafar's red-hot

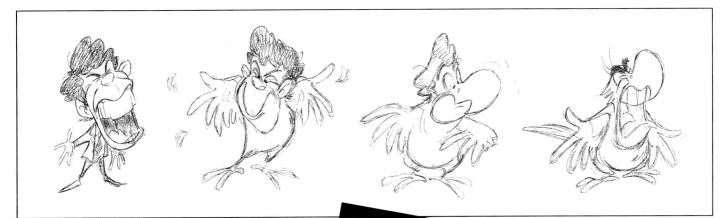

assassination attempts when he walks through a wall of fire toward the camera crying, "A snake, am I?"

Jafar holds his staff up to his face, and the staff dissolves itself into Jafar as he transforms himself into a cobra. But you know he's still Jafar at heart—that black heart—because the hood of the cobra has his colors—a hot red head, with purple under the hood, as he hisses:

"You don't know how snake-like I can be!"

To design Iago, Finn caricatured his voice, comic Gilbert Gottfried, then feathered him.

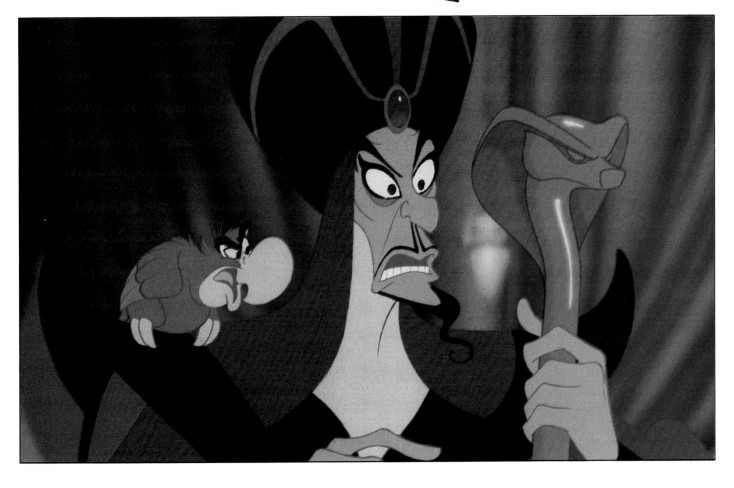

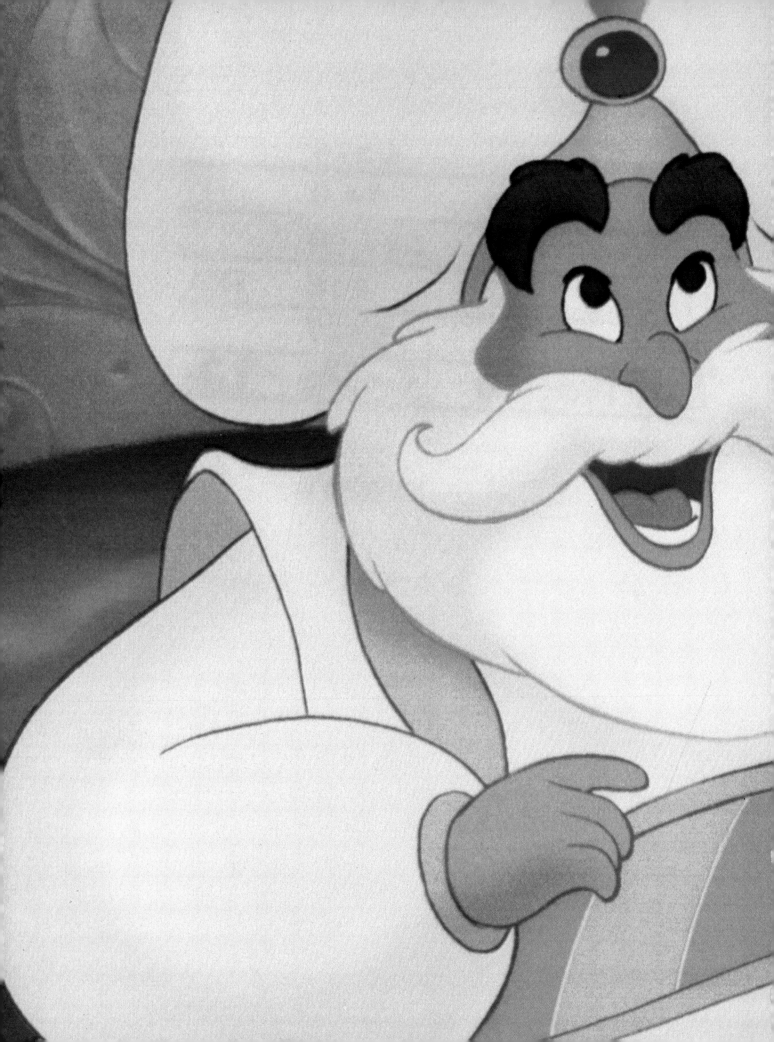

Background to Danger
The Sultan

T he Sultan's throne room is a perfect example of a background that makes as strong a statement about a personality as the animation does. "The Sultan's basic shape is like an egg," said Bill Perkins.

"So when the friendly Sultan's in power, his egg motif is repeated in the column shape, the throne shape, the lamp shape—you can find egg shapes even in the details. But when Jafar takes over the palace, I completely reorganized the shapes in the throne room so that they echo the silhouette of Jafar."

D avid Pruiksma digitizes his drawings so that he can instantly view his rough pencil animation on a desk top computer.

Ominously, the Sultan's elephant throne becomes Jafar's cobra throne. Indeed, the elephant motif becomes a cobra motif throughout the throne room, and the pattern along the top of the room changes from egg shapes to flame shapes, which, if you look close, are a silhouette of Jafar's turban and his shoulders, repeated insidiously, again and again.

The color change in the throne room backgrounds also support the personalities in precisely the ways that Richard Vander Wende intended: The Sultan's environment is the cool blue associated in the film's palette with goodness and idealism; Jafar reigns amid hot reds and the intense yellows of gold, of material wealth.

The Sultan who sits on the elephant throne is apparently an approachable guy. He busies himself planning a model city for his subjects. So we're not surprised that his daughter can say no to him, when it comes to accepting a suitor. But the befuddled Sultan is surprised.

"I don't know where she gets it from," says the Sultan. He cannot for the life of him figure out why his daughter keeps rejecting all the suitors that show up in his throne room. So this guileless little round guy bursts out with what many fathers may subconsciously feel, but are too proud to admit—even to themselves.

"Her mother wasn't nearly so picky."

"I love that line," says David Pruiksma, supervising animator on the Sultan. "It has such an edge to it."

It sounds, in fact, like a childlike Sultan who sits on a child's dream of an elephant throne. Pruiksma based him on Aunt Clara, the befuddled witch played by Marion Lorne on TV's "Bewitched," which he

A nimation art of the Sultan by David Pruiksma. Before recent times, when every Disney animator got such digitizers, two days elapsed before such pencil tests came back from the Camera Department—by which time the animator was usually focused on another scene.

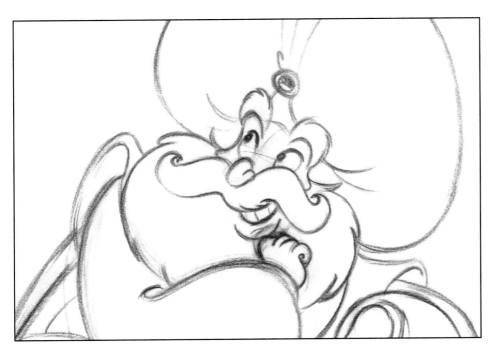

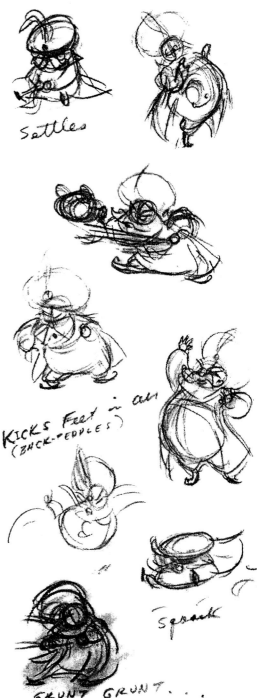

loved growing up; plus Frank Morgan, the Wizard in *The Wizard of Oz*, who is Director John Musker's idea of lovable befuddlement; with the vocal quality of befuddlement provided by the voice of Disney's Sultan, Douglas Seale.

Pruiksma grew up in a Virginia suburb of Washington, D.C., where he watched the Walt Disney television show with his family on Sunday nights, and dreamed of being an animator. Like many children, he made drawings in the corners of his textbooks, and flipped the pages to make the figures move. One day, he saw a little spark of life. To fan that into a flame of personality became his goal.

In two years at the Pratt Institute in Brooklyn, he studied art and some film, but his teachers advised him to go to CalArts, the Disney-funded art school in Valencia, California, if he wanted to learn animation. David did—and was hired by Disney in his second year.

David became an assistant animator on *The Great Mouse Detective*, but made full animator before that first Musker-Clements production was through. When Musker and Clements co-directed *The Little Mermaid*, David Pruiksma was assigned the characters of the seahorse messenger, and, most especially, Flounder, Ariel's appealing fish friend.

On *The Rescuers Down Under*, his assignment was Bernard, Margery Sharp's little mouse from the Mouse Rescue Society, whose voice is Bob Newhart.

"I think *Beauty and the Beast* for most of us was a labor of love," said David. He was assigned the character of Mrs. Potts, the warm, homey teapot, and her cracked-cup son, Chip.

Pruiksma takes his rough animation of the two-dimensional Sultan saying "the picky" line over to a camera in the corner of his room, photographs it himself, drawing by drawing, frame by frame, on low resolution tape, then plays it immediately on his own tiny screen.

Yep, the guilelessness is there in motion in Pruiksma's rough black pencil lines. So is the befuddlement. Beneath the feathered, bejeweled turban, on the

Pruiksma's friendly face for a befuddled Sultan, with his character-exploring thumbnail sketches on the side. Walt Disney always cautioned his character designers to make sure that the characters were appealing from the beginning; Pruiksma's success with Mrs. Potts and Chip, the teapot and son in Beauty and the Beast, showed he had the knack.

Sultan's big-eyed, pendulous-lipped, white-mustachioed, white-bearded face—there is a caricature of the guileless expression that actor-with-pencil Pruiksma rehearsed in the mirror beside his drawing board.

Now he'll show his animation to Ron Clements, who is directing Sequence 5.5, "The Sultan and Jafar." If Clements approves, the drawings can be "cleaned up" by Rick Hoppe, the artist assigned to work with Pruiksma out of Vera Lanpher's ninety-person Cleanup Department. Hoppe is a veteran of animation's definition of courage—graceful drawing under pressure—having cleaned up the drawings of Belle's equally warm and appealing inventor-father Maurice in *Beauty and the Beast*.

The Sultan's throne room is explored at left in tiny color studies and in explorations of the room in line and in light and shade. Finished backgrounds show the friendly-looking Elephant Throne where the Sultan sits amid columns as bulbous as he is; and the user-unfriendly Cobra throne Jafar brings in when he usurps power.

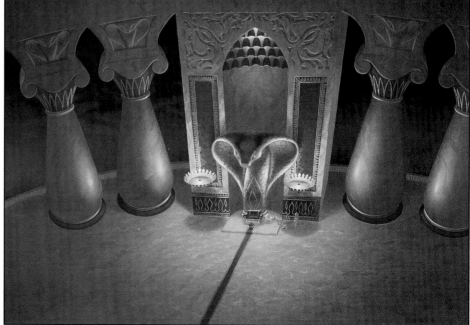

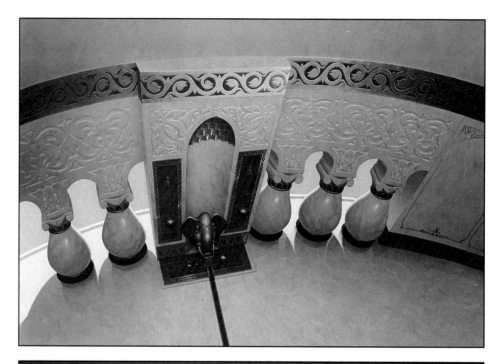

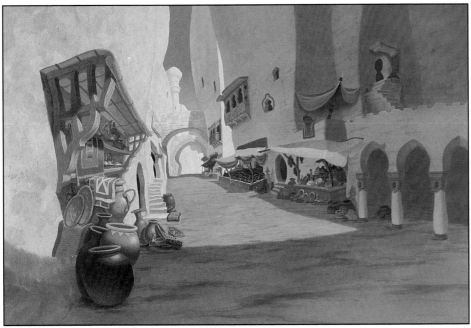

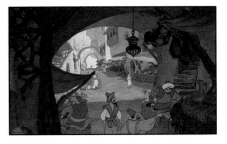

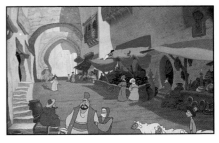

In July, as the animators finished their work—as they had to do if the film was to come out at Thanksgiving—the pressure increased terrifically on the Cleanup Department to complete the whole film by late August—even though most audiences don't even know what the department does.

Vera Lanpher, head of Disney's Cleanup Department, began as an inbetweener on *Pete's Dragon* (1977), finishing the needed number of drawings "in between" those created by the assistant animator and the breakdown artist–the one who "breaks down" the action of a scene and follows the assistant.

But Ms. Lanpher found herself fascinated by the little-understood talents of the so-called cleanup artists, who "cleaned up" the rough drawings of the animators. The animators made the key drawings of the characters in motion, but, as Frank Thomas and Ollie Johnston of Walt Disney's great Nine Old Men of animation put it, "it's the skills of the cleanup artists that make the pictures look so fine on the screen."

The overlays for the background painting of the Agrabah market place make possible a camera move into this environment and, in effect , into the story. When characters are animated against the background paintings and its overlays, the market comes to life.

Usually, that meant placing a fresh sheet of paper over the animator's rough animation on a light board and cleanly and fluidly copying the lines that would turn the "rough" into a finely drawn design in movement.

*I*t was often not understood by audiences that the final living line that is seen on the screen is the work of the cleanup artists. Sometimes, the animator draws slowly and carefully enough so that the cleanup person need only touch up the drawings here and there.

But often, in the passion of capturing the essence of the movement, the animator's lines are too rough—shaggy, even—to have the elegance expected of Disney animation on the screen. Sometimes, the characters don't even look much like themselves—they only move like themselves. The cleanup artist makes sure that every drawing looks like the characters as they are shown on the model sheets.

Vera Lanpher, head of the Cleanup Department, with the character leads: bottom left to right: Vera Lanpher, Debbie Armstrong, Renee Holt, Noney Kniep. Top left to right: Bill Berg, Marty Korth, Alex Topete, Rick Hoppe, Brian Clift.

Rick Hoppe was working closely with David Pruiksma, cleaning up the Sultan. Bill Berg, who was in charge of the Beast character in *Beauty and the Beast*, and collaborated with Glen Keane and all the others who were animating that personality, is in charge of cleaning up all the drawings made of Aladdin by Keane and the other animators in his unit.

Berg made sure that Aladdin looked the same, no matter which of the 14 Aladdin animators drew him, by redrawing every drawing, to a greater or lesser degree, and, because the animator may not do all the drawings in a scene, Berg will add any missing in-betweens at the very end. Some drawings only need a little touching up, an erasing of unnecessary roughness here and there. Most call for a fresh piece of paper to be put over the rough animation, and just the true lines copied. Either way, the important thing is to keep the animator's living lines alive.

Renee Holt, who was in charge of Belle on *Beauty*, was in charge of the animation of Mark Henn's Jasmine unit on *Aladdin*. Marty Korth, who headed Andreas Deja's clean-up unit of *Beauty*'s villain Gaston, was doing the same with the animation of Deja and his unit on *Aladdin*'s villain, Jafar. Debbie Armstrong cleaned up the animation of the Abu unit of Duncan Marjoribanks. Nancy Kniep cleaned up the work of Will Finn's unit on Iago. Alex Topete cleaned up Aaron Blaise's animation of Rajah. Brian Clift worked with Eric Goldberg on the Genie cleanups. They often wished they could simply rub a lamp.

As the summer and the film's production drew to a close, Vera Lanpher, under increasing pressure on a daily basis then, reviewed the work of the eight units of cleanup artists assigned to eight of the nine major characters. (Randy Cartwright's Flying Carpet drawings were being cleaned up and rendered on a computer by Tina Price in a Disney first-ever marriage of personality animation and computer technol-

ogy.) As the tension increases on each feature, Vera often acts as a liaison between the directors, with their vision of how a character should look and act, and the animators, who have their own way of seeing the characters. It is another example of the collaborative nature of animation.

The concentration level around the studio gets pretty intense as the production deadline nears—but concentration, like everything else in life, can be caricatured; can be had fun with by Disney animators.

Dave Pruiksma remembered his father was doing odd jobs around the house—how his concentration would get so intense that he would poke his tongue out as he worked—and Pruiksma gives his dad's protruding tongue to the Sultan when he concentrates on playing with his toys.

Memories of busy parents spurred several Disney artists. Bill Perkins is the son of a painter mother and an advertising artist father.

"My father was busy, like I'm busy right now," said Perkins, "and the only time I saw him was on weekends. Or sometimes I'd go into his office and play around. He had the big Disney book on his shelf in there, *The Art of Walt Disney* by Robert D. Feild, and when I got tired of running around the office building, I sat down and drew pictures from it.

"I always wanted to be a painter. I went to the Art Center in Pasadena, then I asked myself what I wanted to do after school, and what I wanted to do was paint, travel, and make a living with my paintings. In doing that, I met a couple of other painters who had similar feelings, and we put our slides together and submitted for a group show."

But even as Bill Perkins was making a living selling his paintings, he began to think that "it would really be nice to create something bigger than yourself." And so, like artists and artisans from the building of the great cathedrals to the making of tapestries to the huge canvases signed by Peter Paul Rubens on which several individual artists worked, he went to work for Disney.

When Perkins submitted his portfolio, he told a Disney committee that he would like to be an art director. There were no openings for art director, they told him, but he could start out in the layout department and get his sense of staging seen on the screen. His layouts for *The Little Mermaid* attracted the attention of Musker and Clements, and when they began to plan *Aladdin,* they thought of Perkins for the job of sole art director under the artist they planned to make overall production designer, Richard Vander Wende.

"Richard was on this film first," said Perkins. "He was on it before Ron and John. He had done some paintings that attracted Ron and John's eye," said Perkins,

Aladdin environments with hot (Treasure Room), cold (The End of the Earth) and transitional colors—a tunnel that leads the eye from hot reds to cooler blues at the end of the tunnel.

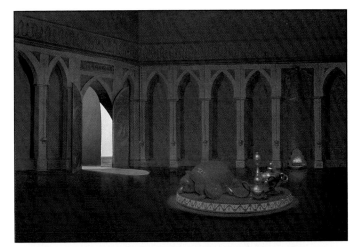

These are seven of the 1,800 photographs Rasoul Azadani took in his hometown of Ispahan, Iran, to inspire the locales of Aladdin. From longshots of architectural arches to details of the marketplace to the kind of dwellings that lead up to the Palace in Aladdin's fictional Agrabah, Azadani's photographs were used by the production designer, the art director, the background painters, and by Azadani himself in the layouts of his department.

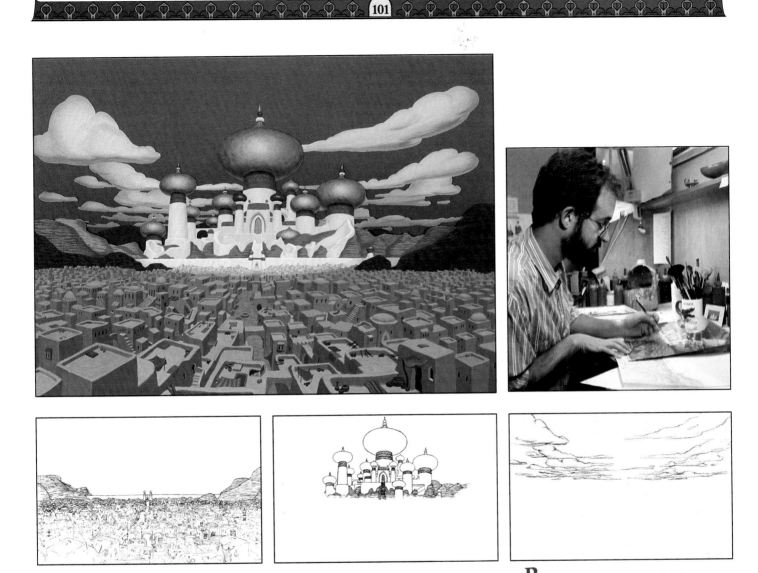

Background painter Dean Gordon paints the Palace from drawings that define some elements of Agrabah—dwellings, Palace, sky. "That'd be the life—huh, Abu?" says Aladdin to his monkey friend. "To be rich...live in a palace...and never have any problems at all." There are problems—and they make for more backgrounds.

as if Clements and Musker were able to see out of the same eye—strong evidence, certainly, of their unified point of view.

So when he came on *Aladdin*, Perkins was putting his painterly talents at the service of a concept already worked out by Vander Wende. Hirschfeld was Eric Goldberg's basic inspiration, and Persian miniatures and Arabic calligraphy were Vander Wende's basic inspiration, and the two inspirations came together in the same type of fluid contour lines to the shapes of both characters and backgrounds.

Before he came to Disney, Richard Vander Wende worked at Industrial Light and Magic, the effects company that George Lucas founded and owns. "I did concept design up there, which is their term for a production designer for effects," said Vander Wende. He worked on *The Golden Child* with Eddie Murphy, and *Star Trek IV*. He did matte paintings for the Star Tours ride at Disneyland.

"Then I got into the concept design area, and designed all the body interiors for *Inner Space*, and I designed the two-headed dragon for *Willow*.

"We wanted the color to be more active on *Aladdin*, and therefore more saturated to do its job. I did a whole articulate color script for the Genie's song. I showed it to Eric Goldberg, and he loved it."

lements and Musker want to get across the idea that Jasmine is trapped in her environment. Linda Larkin, as the voice of Jasmine, will express this by her reading of her lines, and the animators by their creation of her body language and gestures and facial expressions as she says the lines. But the background artists can make this statement, too.

"Jasmine is a bird in a cage," said Bill Perkins. "Her canopy bed is a bird cage. The columns in her room are her silhouetted shape. The design on the wall is very close to her shape. The lamps that are hanging in front of the columns cast a light pattern on her curtains, her drapes, that is a silhouetted peacock shape. So everything fits together to give the room a point of view."

When he finished his work as a layout artist on *The Little Mermaid*, Perkins went to the Disney library at the studio in Burbank for two weeks to do research on the similarities and differences between the styles of *101 Dalmatians*, *Lady and the Tramp*, and *Sleeping Beauty*.

"All three are Disney classics, remembered for their look. Well, I looked at world art history at the same time. I found that all three films are made up of the same three elements—you can't escape it. There is line, there is mass, and there is form. I was trained in school to deal with those three principles. It's just a case of prioritizing."

Top: Kathy Altieri paints a background of the Cave of Wonders. Below: A single environment often requires many different background paintings to satisfy the needs of different camera angles, including aerial view at extreme right of the Stairway to the Lamp in the Inner Cave.

It's the old design principle: dominance creates unity.

"The dominant element in *101 Dalmatians* was line. The dominant element in *Lady and the Tramp* was form. The dominant element in *Sleeping Beauty* was mass. There was an incredible amount of detail. You remember the trees in the forest—they looked trimmed in specific shapes."

"After laying out the art work from those three films, I jumped back into art history books. I went through different movements in art history, and what the work really illustrated was a clear vision of a period's priority among the three principles. For example, Matisse is line first and form last.

"When I came to Persian miniatures, I saw that it is mass-oriented first and foremost. There is an incredible amount of detail, but it's all bordered within a silhouetted shape—which makes the mass most dominant. The texture patterns are isolated by the silhouetted shapes.

"So I asked myself, 'Okay, what is the most important of the three elements in this film? And since we were referencing the Persian miniatures, and mass was clearly the dominant aspect of that work, I felt it should be dominant in our film, as well.

"Mass, silhouetted shape, is a shoe-in with animation because everything with animation is a silhouetted pose. Your characters have to be readable in silhou-

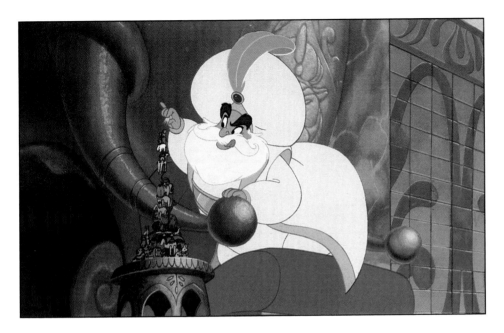

ette. As the characters were being developed, they had these simple shapes. And what I did is just abstracted the shapes. Aladdin has a fairly high waist, broad shoulders, and a wide, stable stance. Okay, that's our hero. Jasmine has narrower shoulders, a high waist and high hips tapering down—she's more delicate than Aladdin. Her father, the Sultan, is basically an egg. Jafar is tall, narrow, more angular, and has broad shoulders that are overexaggerated, that flare out at the top.

"The Genie has no center of gravity. He's top-heavy. And the Carpet is characterized in poses, so it never really appears as just a flat," Perkins continued.

"Actually, what I did during the character design meetings was to draw these basic shapes and stick them on the wall and talk to the animators about them. I was looking for an abstract design quality that I could pull from the characters to work into their environments. I wanted to create worlds that the characters would fit in.

"Collaboratively, these meetings were very constructive. Each animator came in with his sketches for his individual character, and we went through them and had a forum, and talked about the positive and negative things about the drawings."

Everyone's goal was a shape that could be animated and express a believable personality.

"They're really thinking of personality first—which is as it should be. What I was doing was trying to synthesize what was growing there in those meetings, and use those elements to create environments for those characters," said Perkins.

It works subliminally. You see his throne room, you think, "Hey, the Sultan's a good egg."

In David Pruiksma's animation drawing of the Sultan concentrating on playing with his toys, the Sultan pokes his tongue out because "my father always did that when he was concentrating on fixing things around the house." The toys are shown in detail above right. The whole scene is composited at upper left. (See if you can find the in-joke the animators included in this stack of toys.)

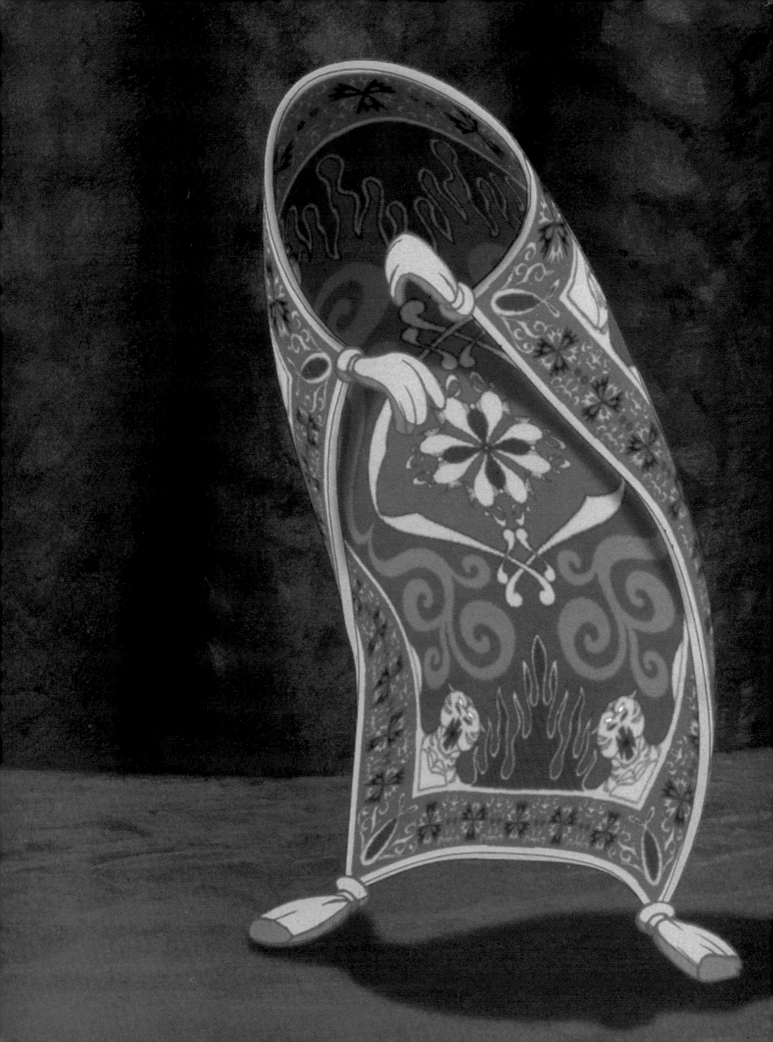

Cartw...
young woman...
girl, Penny, un...
Elliott in *Pete'...*
character of Sc...

On a...
Cartwright–El...
Studio building...
refolding a piec...
teen inches lor...
imagine how th...
"new friend" ge...
his new friend,...
rewinding the k...
tiny drum whe...
mechanical moti...

"It's a c...
ment. "The Carp...
has no body. It'...
can't use any of...
have to figure ou...
that I give an im...
his head.

"Oh, yea...
added. "That's a re...
shrugs.' The dictic...
the Carpet has no s...

Cartwrigh...
or bend from a ve...

He quickl...
1. Head ti...
2. Should...
3. Arms o...

CURIO

When John Musker described the flying Magic Carpet as "a pantomime character—doesn't speak at all—but, in the Disney tradition, he has a personality," he was connecting that reacting rug, of course, with the greatest pantomime character in the Disney tradition—Dopey, the voiceless dwarf in *Snow White*.

FX: Pencils Meet Computers
The Magic Carpet

But how do you do that if your character has no head, has no shoulders, and has no arms?

See the film.

Ed Gombert, head of story, made the first sketches of the Carpet. John Musker threw in a few quick sketches to point the Carpet in the direction in which he wanted it to fly. They gave Cartwright a personality godsend: four tassels.

A real Persian carpet inspired Richard Vander Wende to design a carpet personality whose pattern is made up of lamps, scimitars, tiger's heads and flames—all motifs in the film. Rendered as a computer element into the animated outline of a rug, it becomes the Magic Carpet in scenes like the one here in the Cave of Wonders.

"The one element I have to work with is the tassels, which give the impression of arms and legs," he said. "I can create the impression of a head by folding the Carpet over and having the tassels act like arms and legs in an attitude that makes

Randy Cartwrigh[t]
of the Magic Carpe[t]
the flying rug. A m[...]
tion of pose and m[...]
mated emotion, Ca[...]
letin board above h[...]
Carpet thumbnails [...]
al poses like the eig[ht]
these pages.

you imagine the expression on the face—and if you imagine the expression on the face, of course, you're imagining the head."

He showed me a drawing of the Carpet laughing—the way we laugh when we hold our stomachs with our left hand and raise our right hand in the "Oh, that's a good one" pose. Try to imagine a friend in that pose without imagining the friend's face, too. Thus is imagination's magic created. As with all effective caricature, less is more.

Another day, the Magic Carpet and the Genie were glad to see each other, in the drawings that flowed from the pencils of Joe Haidar, an animator in Eric Goldberg's unit, animating the Genie in one room; and Cartwright, in another part of the building.

"Yo, Rugman!" says the Genie. "Haven't seen you in a few millennia. Give me some tassel!"

Randy animates the key drawings of that seventy-four frame scene—more than three seconds of screen time the way the artist staged it—as a medium two-shot of the Carpet and the Genie's hand. The Carpet slaps the Genie's hand with a tassel, high and then low.

"Hey…Yo! Yo!" yells the visibly elated Genie.

Believability is what Walt said that Disney animation is after—but an intricately-patterned Persian carpet giving a Genie the high sign? C'mon.

EXCIT[...]

But they can do it, and they know how. This is a job for an animator like Cartwright, who believes in what animators call the plausible impossible, relying on S/FX (special effects) to give an air of reality to the scene.

In my 1981 book, *Special Effects in the Movies*, I got my very definition of special effects from a Disney wizard, two time Oscar-winner, Eustace Lycett.

"A special effect in a motion picture is any technique or device that is used to create an illusion of reality in a situation where it is not possible, economical, or safe to use the real things," said Lycett, then retired head of the photographic effects department at the Walt Disney studio.

Well, it is not possible to make a carpet fly or to slap palms with a genie if genies are only make-believe and carpets don't have palms. And if you solved that problem by simulating the same in animation it would still not be economical to paint an intricate Persian carpet pattern on every single frame of film. And if you don't have the carpet pattern, all you have is an animated rectangle pretending to be a carpet, and then, as Br'er Bear used to say, "You ain't foolin' nobody."

Ah, but that's where the special effect comes in—CGI, computer-generated imagery.

But let's begin with the original idea of John Musker and Ron Clements.

"We also have a flying Magic Carpet," John Musker told the work-in-progress screening in New York City. "He has the personality of an overeager and slightly lonely puppy."

After Randy Cartwright has made the Carpet move on paper, Tina Price, the computer animator charged with digitizing feature animation's first-ever computer-animated character with a personality takes over.

Tina Price renders Randy Cartwright's hand animation of the Carpet as a computer element, then zaps into each computer-animated rectangle the painted carpet texture, adapted by her eye to the ever-changing Carpet contour.

Tina began as a hands-on animator, notably on the little mouse who sings in the London bar in *The Great Mouse Detective*, and went on to work on CGI elements for *Oliver and Company* and *The Little Mermaid*.

"I have to turn Randy's drawings into digital information that I can read," Tina explained. "So a picture is taken of each drawing by a digital camera, and then I can load it up into my software. I go through those drawings just as if I were going through them as a follow-up animator. I take the extremes first, and I construct the carpet into poses on the computer, and I let the computer do the in-betweens. Then I go back and tweak the in-betweens—because the computer just wants to do straight-ahead in-betweens."

To tweak means here to move a computer drawing toward a state that is pleasing to the human eye.

"The computer doesn't know anything about animation timing, it doesn't know anything about arc-ing, and slow-in and slow-out," said Tina. "It just wants to

do straight in-betweens. Well, with my animation background, I go back into the computer and make the timing nonlinear, and hopefully a little bit more interesting."

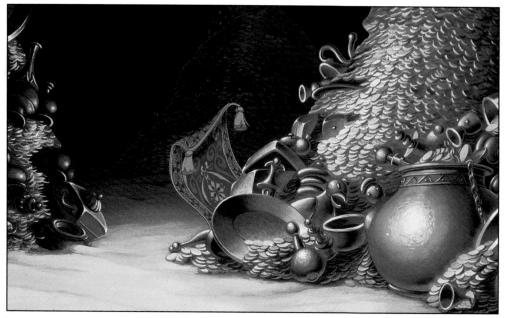

The Magic Carpet peeks from behind piles of gold coins, glinting and glowing with special effects.

In fact, she makes the computer-generated drawings a lot more interesting by injecting the human element that her fellow humans react to as if the Carpet had, well, personality.

In addition to the enhancement for the Carpet, even some of the environments the Carpet flies through are computer-generated, just as was the ballroom in which Beauty and the Beast waltzed.

The Big Four computer-enhanced effects in *Aladdin* are the Flying Carpet's textured pattern, the boiling lava of the Havoc sequence, the rollercoaster-like escape from the Cave of Wonders, and the sand-shedding, rim-lighted wonder of the huge Tiger's Head that rises up out of the trembling desert, formed from the sand itself.

Up on the screen, a bright, white light blasts out of the cavelike mouth of the Tiger.

"WHO DISTURBS MY SLUMBER?" roars the Tiger-God, in the reverberating voice of Frank Welker, an actor who also provided the voice of Abu.

Down in my seat in the screening room, I asked myself, "How'd they do it?" The Tiger-God's moves do not have the airless mechanical quality of so much animation done with a computer alone.

In Supervising CGI Animator Steve Goldberg's room at the studio, I found out. On either side of Steve's computer terminal, there were two large white models of the Tiger's Head—one with its mouth wide open, displaying its cavelike interior; the other with its Tiger's Mouth shut. The white surfaces of both models were covered with black grid lines, which were guiding Goldberg as he worked to "get the model inside of the computer."

"The whole idea of getting the model inside of the computer is so that we can view this model from any angle," said Goldberg, a master animator of CGI. "Working with Rasoul Azadani, we set up his layouts like this—with me actually sitting in front of my computer."

Using the grid lines as reference points, he makes a rendering in line on the screen representing the models on his desk, until the shapes on his computer screen seem to be three-dimensional volumes as well as shapes—giving the illusion of occupying space as truly as the models on his desk.

It is what designers do at automobile companies in Detroit when they design a new model car. Once they have represented the car as a three-dimensional volume in their computer, they can turn the drawing in any direction on the screen—as if

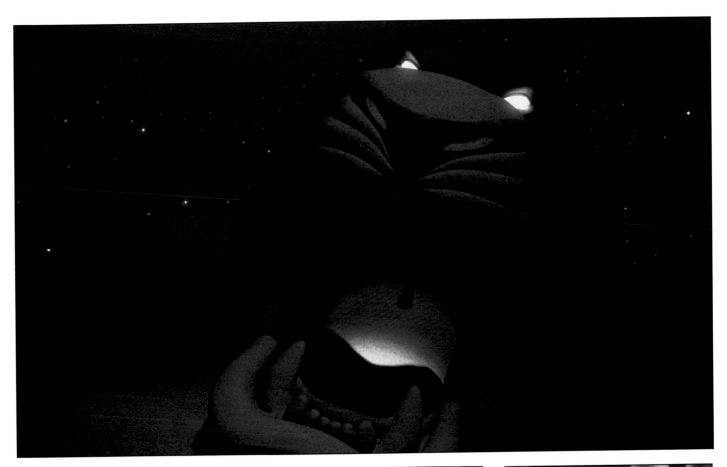

Steve Goldberg (seated) animates a three-dimensional model of the Tiger-God on his computer screen using the timing worked out by hand animator Eric Goldberg (no kin) as Ed Kummer, CGI renderer, looks on. In the film, the Tiger-God rises out of the desert when two pieces of magic scarab are put together, opens his computer-animated jaws, and swallows the hapless Gazeem, hand-animated by T. Dan Hofstedt.

there were actually a miniaturized model car in there. Similarly, the Tiger-God now turns from profile to full-face on Steve Goldberg's screen as if he were miniaturized and imprisoned inside Goldberg's computer.

"You see, once you've got your model inside of the computer, it's a three-dimensional database," Steve explained. "It's analogous to the motion-control stage

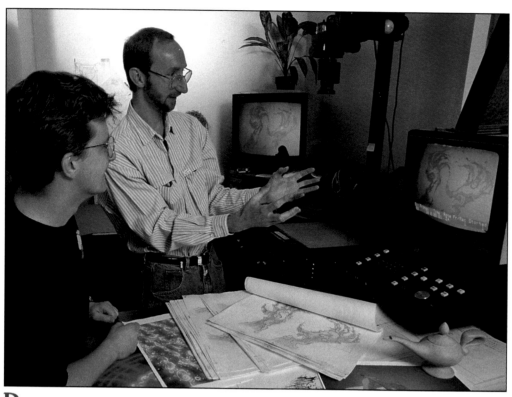

in special effects on which you put models and miniatures."

Nevertheless, Steve Goldberg's computer animation of the Tiger's Head follows the pencil animation of Eric Goldberg.

"Our process is this," said Steve. "Eric Goldberg will rough out the animation for us, and indicate the in-betweens using timing charts instead of through standard animation technique. Once I get the model of the Tiger's Head in the computer, I match my movements to his key frames, so in a way I'm sculpting the model. I'll move from one key frame to another, based on his timing charts. I'll assign those the frame numbers, and then we will go ahead and Ed Kummer will render it.

"When we've got computer animation that matches Eric Goldberg's pencil animation timing, and our key frames—the extremes of the action—match his key drawings, we have, in essence, duplicated his animation, which is on the paper, into a three-dimensional version of his animation, in the computer.

"What Tina Price is doing with Randy Cartwright's pencil animation of the Magic Carpet is to bring up Randy's drawings as a guide on the computer, and match her computer animation to that. We can't really do that with the Tiger's Head,

Don Paul, Special Effects Supervisor, and Chris Jenkins, Effects Animator, go over some of the art that makes Aladdin a special effects extravaganza. The rounded, cursive and flowing forms of Arabic script can be seen in the large, swinging curves of some effects, while others make Aladdin a kind of Arabian Nights light show.

because of the complexity of this model; so I'm using Eric Goldberg's pencil animation as a visual reference. I'll look at one of his drawings; I'll look at my computer; and I'll go ahead and 'push' my model—'sculpt it' in the computer, I like to say—to match his key frames."

Other animators from the effects department will add the grains of sand that seem to tumble off the head as it rises, and the rim-lights on the Tiger-God's eyes, making us believe that the Tiger-God actually rose out of the desert, alive and glowing, just as the special effects "water" Grumpy shook from his pencil-drawing beard made us believe that he really had been dunked in a wash tub.

This sudden, sandy, carefully animated awakening makes real the Tiger-God's red-eyed, irascible roar:

"WHO DISTURBS MY SLUMBER?"

From the Tiger God to the Havoc's lava, the range of computer-generated effects in *Aladdin* is wide. But the most fanciful use of special effects is probably the hand-drawn effects that we see when the Genie's magic is being accomplished. Back in 1939, when Disney was making *Pinocchio*, Oskar Fischinger, the abstract filmmaker from Germany, designed the hilations that come from the Blue Fairy's wand when she gives the gift of life to the little woodenhead. They were composed of an animated pattern of wavy lines in white ink. In later years, magic wands gave forth what has come to be known as Disney dust.

"For this show," said Don Paul, "we were trying to stylize the effects to make them more arabesque in design. The smoke we animate has Persian swirls to it based on early Persian designs. I wanted our effects to stand out as apart from normal effects on other shows. We all know the look of traditional, standard special effects that don't look any different from feature to feature. That's not for *Aladdin*."

Paul pointed to a picture of the Genie's magic.

"There's more of a swirl to the design. We based our magic on Arabic calligraphy. We took the letter styles and tried to animate them to make our magic effects."

Don Paul laughed.

"We try not to hold their shapes too long. Otherwise, we may be saying words that we don't know we're saying."

As Mickey the Sorcerer's Apprentice found out long ago, when you're fooling with magic, you've got to watch what you say.

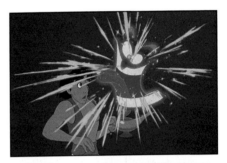

In finished frames (at top left), Jafar puts together the two pieces of the magic scarab. It begins to glow with hand-animated effects and produces the computer-animated Tiger-God.

CONCLUSION

Show Stopper

Animation invites us to a form of theater in which, as Charlie Chaplin
once pointed out, "the artist is absolutely free to use his fantasy and to do
whatever he likes to do with the picture."
Consider "Prince Ali," animation's equivalent of the big stage
production number that pulls out all the stops. As Aladdin parades through the
streets of Agrabah on his way to play the Sultan's Palace disguised as
Prince Ali Ababwa, the city's balconies fill with young women delighted
by the young man's grand kiss-blowing shenanigans.

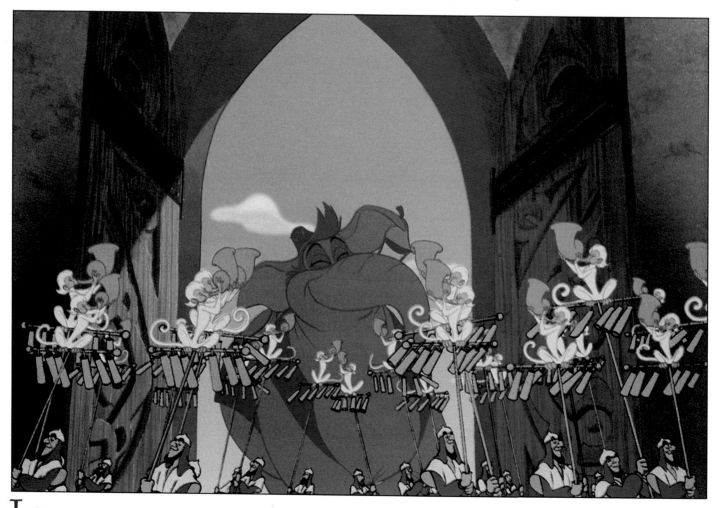

Truck in on an Elephant marching down the street while the Genie sings, "Prince Ali, Fabulous He, Ali Ababwa!"

In the new Disney animated musical, this is becoming the big screen equivalent of the Broadway show stopper. In *The Little Mermaid*, a chorus of grasshoppers, pelicans, flamingos, frogs, ducks, and turtles provided the "doo-wop" harmonies for "Kiss the Girl": in *Beauty and the Beast*, "Be Our Guest" arrayed a chorus line of animated knives, forks, spoons, plates, cups and saucers; but "Prince Ali" reaches for the ultimate in "plussing" production numbers by providing exotic march music for a panoramic parade impossible even for the greatest circus on earth. "Prince Ali" rides an elephant bigger than Jumbo; there's an animated bestiary that Genie & Chorus describe as a "world-class menagerie," and an out-of-this world climax in which the elephant bursts through the Palace door, smashing villainous Jafar and Iago flat against a marble wall. Match that, Broadway musicals!

And Ziegfeld himself couldn't give us a magic carpet ride clear around the world, from old Agrabah to the banks of the Nile through an Eden of an apple orchard to China in time for the fireworks. But animation can—and does.

"Howard Ashman and I had always discussed a magic carpet ride," said Alan Menken. "Howard and I never got to it. Howard died, and Tim Rice joined us,

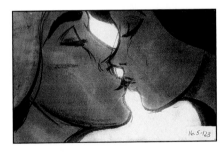

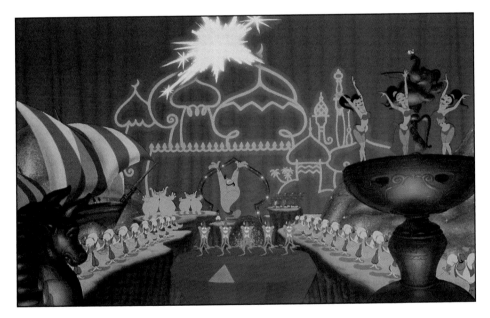

and, finally, Tim and I wrote a ballad for the magic ride moment which I think is going to end up being a very big contribution to this project. It's called 'A Whole New World.'"

The storyboards for Sequence 16.5, called Magic Carpet Ride and to be directed by John Musker, did indeed promise a beautiful moment in the film. It promised a sense of traveling through space such as animation has seldom attempted. All over the studio, as the scenes were handed out and animated, stereos played tapes of the song by Alan Menken and Tim Rice, as animators sought inspiration from the words and music:

"A whole new world/a new fantastic point of view/no one to tell us no, or where to go/or say we're only dreaming."

Aladdin and Jasmine, on the Carpet, rise toward the camera. They both look over their shoulders. As they fly away, we see the city below from their point of

When the Genie puts on a busy, breezy, neonlighted, kaleidoscopic, super-entropic Spectacle (above left), it makes Las Vegas look like Little House on the Desert. And not since Romeo and Juliet has there been such a balcony scene as love's first kiss. If you like the storyboard, you'll love the movie!

view until the city disappears in the clouds. They fly in and out of the clouds—they fly past the moon.

The Jasmine unit—Mark Henn, Doug Krohn, and Aaron Blaise—drew to a conclusion with this sequence, coordinating their work with Aladdin animator Mike Cedeno. Meanwhile, Randy Cartwright and Tina Price were worrying about the Carpet itself, who had a flower to pick and hand—er, tassel—to Aladdin, who would place the flower in Jasmine's hair. And so Sequence 16.5, Magic Carpet Ride, made its way through the pipeline, with each artist and technician trying to make it a little more of the dream experience we have in our heads when we are in love.

The dream of great animated musical comedy that began with Walt Disney's Silly Symphonies is entering a new age with *Aladdin*. Just as the Genie shows him-

The Magic Carpet ride is accompanied by a new Alan Menken—Tim Rice love song, "A Whole New World."

Not since Ninevah—or at least Busby Berkeley—has there been such spectacle: three two-fisted shish-kebob bearers—count 'em, one, two and three !

All the Camels join in—and the Carpet cuts a rug.

self capable of endless transformations, the medium itself is capable of endless permutations of words, music and designs in motion and color, making animated personalities and stories that we suddenly discover are unforgettable. To touch our hearts, to tickle our funnybones, to remind us of where we have been before, and to transport us to whole new worlds, to remind ourselves that we can crawl in the mire or aim for the stars, for all these reasons and many more, human beings created theater. In this house of the human spirit there are many mansions. Animation lives in one of them, and currently the characters from *Aladdin* are holding a celebration there. It is a celebration that harmonizes Hamlet's "what a piece of work is a man!…in moving, how express and admirable!" with Puck's "Lord, what fools these mortals be!" Yet even Shakespeare never said it better than Disney's Genie:

"So why don't you just ruminate whilst I illuminate the possibilities!"

Index

Page numbers in *italics* refer to illustrations.

John Culhane sketched by Glen Keane as he lectured
on Disney animation at St.Louis University, 1981.

John Culhane

When John Culhane was 17, he visited Walt Disney in his California backyard to tell Disney that his ambition was to write for and about the art of animation. "Walt gave me the best writing advice I ever got," says Culhane. "He said, 'Go to work for your home-town newspaper, write for your neighbors—and just keep widening the circle.'" After a Jesuit education at St. Louis University, Culhane went back to his hometown of Rockford, Illinois, and became a reporter and daily columnist for the *Rockford Register-Republic*; then a Sigma Delta Chi prize-winning investigative reporter for the *Chicago Daily News*, a Ford fellow in Advanced International Reporting at the Columbia University Graduate School of Journalism, a foreign correspondent for the *Chicago Daily News Foreign Service*, an editor at *Newsweek*, and a Roving Editor of *Reader's Digest*. He has written 20 articles for the *New York Times Magazine*, notably a cover story on Disney animation after Walt. His work also appears in periodicals from the *Chicago Tribune* to the *Los Angeles Times Calendar* section. He is the author of *Walt Disney's Fantasia*; *Special Effects in the Movies*; *The American Circus: An Illustrated History*, and, for television, *Backstage at Disney's*. With his cousin, "Snow White" animator Shamus Culhane, he has written three animated television specials, *Noah's Animals*, *King of the Beasts*, and *Last of the Red-Hot Dragons*—for which he was the voice of the dragon. In 1972, at the School of Visual Arts in Manhattan, he created the first course in the history of animation for college credit, and he has lectured on the medium from the Museum of Modern Art and Lincoln Center in New York City to the Kennedy Center in Washington to the California Institute of the Arts and 39 other universities and colleges in the United States, Canada, Europe and the Middle East. With his wife, Dr. Hind Rassam Culhane of Mercy College in Dobbs Ferry, New York, and their sons, Michael and T. H., John Culhane is currently collaborating on *1,001 Nights in Arabian Cinemas: A History of the Egyptian Film*. He is listed in the 1992–93 Who's Who in America.

Additional art credits: p 10: Drawing of Aladdin by Glen Keane, Drawing of Jasmine by Mark Henn, Drawing of Jafar and Iago by Andreas Deja and Tony Bancroft, respectively, p 11: Carpet and monkey by Duncan Marjoribanks and Randy Cartwright, respectively, Sultan by David Pruiksma, Genie by Eric Goldberg, p 15: Sultan (top) by Burny Mattinson, bottom of pp 14-16: John Musker and Ed Gombert, p 19: storyboards by Ed Gombert and Darrell Rooney, p 24: Genie by Joe Haidar, 28: Genies by Eric Goldberg, 32: Genies by Eric Goldberg, p 34: Genie woman and bowtie Genie by Dave Burgess, William Buckley Genie by Mike Swofford, Jack Nicholson Genie by Joe Haidar, p 35: Genie with mike by Eric Goldberg, Genie with crab by Dave Burgess, p 39: Jasmine by Mark Henn, p 45: Jasmine by Doug Krohn, p 47: Jasmine by Mark Henn, p 57: Monkey by Duncan Marjoribanks, Carpet by Randy Cartwright, p 65: Aladdin's top and bottom, by Glen Keane, p 85: (bottom of page, left to right) first drawing by Kevin Donoghue, next two by Francis Levas; fourth by Sue Nichols, fifth by Andreas Deja.